COMIC RELEASE: A humorous or farcical interlude in a serious work, especially a tragedy, intended to relieve the dramatic tension or heighten the emotional impact by means of contrast.

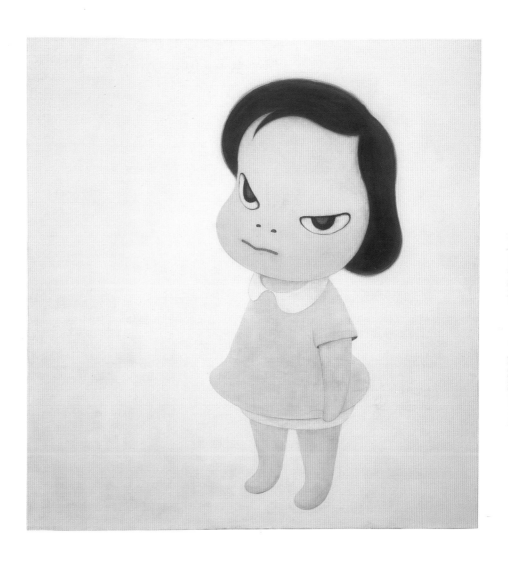

**YOSHITOMO NARA** *All the World is Yours*, 2000
Acrylic and colored pencil on canvas
79 x 75 inches
Courtesy Blum & Poe, Santa Monica, CA
Photo: Joshua White

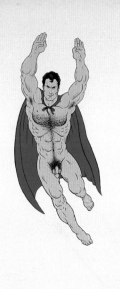

# Comic Release

**NEGOTIATING IDENTITY FOR
A NEW GENERATION**

Curated by Vicky A. Clark and Barbara Bloemink
with Ana Merino and Rick Gribenas

Published by D.A.P./Distributed Art Publishers, Inc., New York
in association with The Regina Gouger Miller Gallery at Carnegie Mellon University
and Pittsburgh Center for the Arts

# Contents

# THE COMIC RELEASE DUO

BY ROB ROGERS

AS THE SUN SET ON THE CITY, TWO AESTHETIC HEROES SEARCHED FOR NEW WAYS TO BRING ART TO THE PEOPLE...

THEY VISITED GALLERIES...

WENT TO THE MOVIES...

SPIDERMAN PG-13

AND WATCHED TV...

#@☆!

IT WAS UNDER THEIR NOSES ALL ALONG...

WHY WOULD SOMEONE THROW OUT THOSE GEMS?

LOOK... A BOX OF COMICS.

COMICS

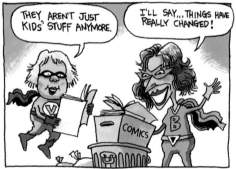

THEY AREN'T JUST KIDS' STUFF ANYMORE.

I'LL SAY... THINGS HAVE REALLY CHANGED!

COMICS

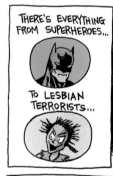

THERE'S EVERYTHING FROM SUPERHEROES...

TO LESBIAN TERRORISTS...

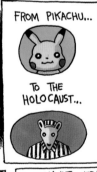

FROM PIKACHU...

TO THE HOLOCAUST...

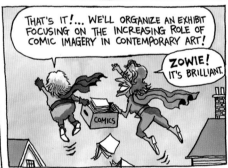

THAT'S IT!... WE'LL ORGANIZE AN EXHIBIT FOCUSING ON THE INCREASING ROLE OF COMIC IMAGERY IN CONTEMPORARY ART!

ZOWIE! IT'S BRILLIANT.

COMICS

WE'LL SEARCH FAR AND WIDE FOR WORK TO INCLUDE...

STAY "TOONED" AS VICKY, BARBARA & THEIR TRUSTY SIDEKICKS (BECAUSE ALL SUPERHEROES NEED SIDEKICKS) ANA AND RICK, TURN THE ART WORLD UPSIDE DOWN!

VICKY

BARBARA

ANA

RICK

MOM... HAVE YOU SEEN MY BOX OF VALUABLE VINTAGE COMIC BOOKS?

OOPS.

# Introduction

DISCLAIMER: We are both middle-aged curators attempting to come to terms with a changing culture. Neither one of us was a fan of comics as a child, especially since we did not fall into the target market of adolescent boys. Would it be possible for us to make sense of comic and cartoon imagery and of why it was suddenly appearing everywhere?

It is impossible to replicate here the energetic and engaged discussions we have had over the last three years as we put together this exhibition and publication. The process unfolded in many locations: in New York City in restaurants, galleries, the subway, and taxis; in Pittsburgh in Vicky's office and house; in Las Vegas in Barbara's office and house; at the Navy Pier Show in Chicago; and in the more ephemeral space of phone calls, faxes, and e-mails. We shipped tons of material from place to place, we talked to many colleagues, we used the Internet, we read a lot, we saw a lot of shows, and we talked, talked, and talked over pots of coffee and bottles of wine. We have not always been in complete agreement, but it was amazing how often we had the same idea at the same time.

It soon became clear that as comics and cartoon imagery enter the mainstream of society and art museums, they continue a narrative tradition at a time when nonlinear thinking and hybrid forms are the norm. Most of the work we looked at represented attempts to share personal stories and to negotiate identity in new ways via a new language. As such, these works extend the trajectory of many key artists from the 1980s and 1990s who initiated the genre of identity politics.

As the works in this exhibition demonstrate, international artists are increasingly using cartoon imagery and graphic styles to address difficult, controversial subject matter that would be hard to assimilate in realistic depictions. The works address issues such as race, gender, sexual orientation, violence and war, loss of innocence, and religion through a variety of media, including painting and sculpture, high- and low-tech animation, zines, design, comic strips, and graphic novels.

In order to keep the scale of the exhibition manageable, we chose to concentrate on younger, less established artists and on work of the last decade. Not believing in the modernist "high/low" trap of privileging artists who make paintings or sculptures over those who create graphic novels or comic strips, we treated them all as equals in both the exhibition and our essays. In addition, to reflect the portability and the variety of zines, we decided to display a large number of contemporary zines so they can be picked up and read by visitors to the exhibition.

The most difficult point came when we knew we had to stop. The show was very large and we had no more time, yet we kept discovering new artists—proof of the continuing vitality of these forms and images.

VICKY A. CLARK    BARBARA BLOEMINK

# Acknowledgments

We are extremely pleased to present *Comic Release: Negotiating Identity for a New Generation* at our three-year old Regina Gouger Miller Gallery. The number and range of artists in this provocative show promise a heady viewing experience for our university community as well as the larger public in Pittsburgh. We are also happy to collaborate with Vicky A. Clark, an adjunct associate professor in our School of Art who brought us this project. We thank her and her curatorial team of Barbara Bloemink, Rick Gribenas (the exhibitions coordinator at the Miller Gallery), and Ana Merino. Sharing an obsession, they joined forces, and through periods of excitement, frustration and inspiration, brought their ideas to fruition in this exhibition and book. Together Vicky and Barbara decided to focus on identity and chose the artists based on their wide contacts and experience. Ana's knowledge, insights, contacts and enthusiasm made this show appreciably better as she organized the comic and graphic novel artists. Rick added a whole range of different voices by working on the zine section.

I am grateful to the funders who allowed us to reach beyond our normal means: Regina Gouger Miller and Marlin Miller gave generously early to the show, allowing us to proceed, and the contributions from The Heinz Endowments and the National Endowment for the Arts showed a belief in both the gallery and the show. The Pennsylvania Council on the Arts and the Juliet Lea Hillman Simonds Foundation also supported this show.

The exhibition was originally scheduled for the Pittsburgh Center for the Arts where early stages of research and travel were funded by The Andy Warhol Foundation for Visual Arts and the Pennsylvania Council on the Arts. The Elizabeth Firestone Graham Foundation contributed to the book and graciously agreed to transfer the money to us for the catalogue. We appreciate the willingness of Lou Karas, acting executive director at the Center, to help see that funds were transferred. Because of their contributions, the catalogue is co-published by the Center.

Even before the change in venue, Pamela Auchincloss became involved, organizing the travel schedule for the show. She and her staff, especially Christopher Saunders, got more than they bargained for as they became the key organizers of the show, negotiating loans and reproductions for the catalogue. We never could have made this happen without their hard work and dedication. We would also like to acknowledge our colleagues in the institutions that will host this exhibition: David Rubin at the Contemporary Center for the Arts in New Orleans, Diana Block at the University of North Texas, and Sarah Clark-Langager in Bellingham.

D.A.P. was another early supporter, becoming the co-publisher of the catalogue. This allowed us to realize a much more comprehensive book, and we appreciate the efforts of Lori Waxman and Sharon Gallagher. Michelle Piranio used skill and tact as she deftly edited our essays to make a cohesive book. The Feel Good Anyway team of Bill Morrison and Matt Eller did likewise for the book's design.

Several individuals at Carnegie Mellon helped to realize this project. Chris File and Sue Tolmer worked on raising money; former director of the Miller Gallery, Petra Fallaux, initiated discussions about hosting the show; Rick Gribenas took on all the details for the gallery including installation. We are grateful to all of them.

No exhibition can happen without the cooperation of the many artists and lenders, and words cannot express our belief in the talent of the artists nor our gratitude to those who parted with their work for the run of the show. In addition to the lenders, listed elsewhere, we would like to thank the following individuals who helped to secure the loans: Randy Sommer and Robert Gunderman, George Adams, Tim Blum, Janet Oh, Catherine Clark and Anna Rainer, Elizabeth Burke, Byron Cohen, Mary Dohne, Valérie Cueto, Elizabeth Schwartz, Andrew Freiser, Federica, Carroll Case, Jack Hanley, Richard Heller, Ruth Phaneuf, Scott Lawrimore, Penny Liebman and Kathy Magnan, David Lusk, Bill Maynes, Katya Kashkooli, Magda Sawon, Paul Kotuli, Bennett Roberts, Christian Viveros-Faune and Joel Beck, Andrea Rosen, Jack Shainman, Brent Sikkema and Michael Jenkins, Mari Spirito.

Comic Release is a large undertaking, and so many people have contributed to make it happen. We thank all of them.

MARTIN PREKOP
STANLEY AND MARCIA GUMBERG DEAN
College of Fine Arts, Carnegie Mellon University

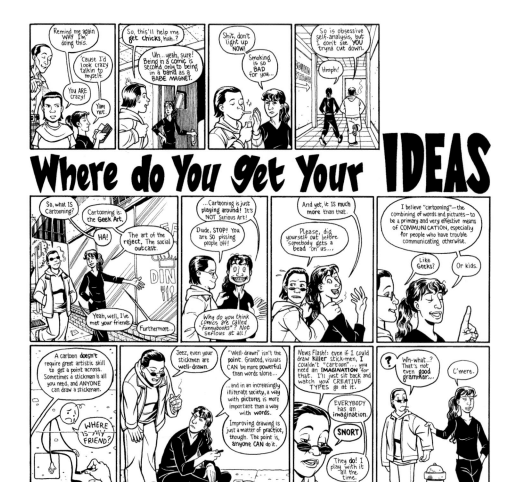

# Where do You get Your IDEAS

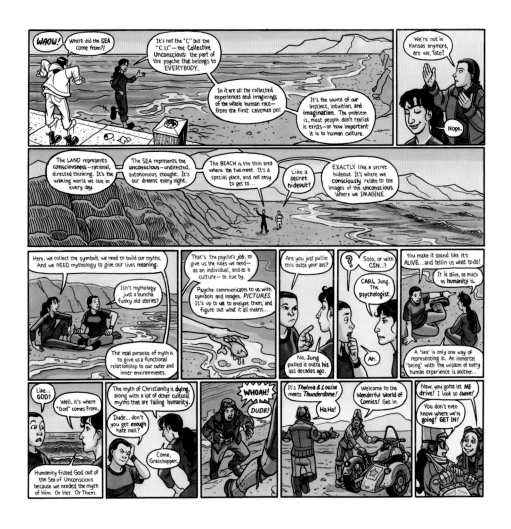

LINDA MEDLEY  *Where Do You Get Your Ideas* (pages 1 and 2)
From *The Comics Journal* (Winter Special), 2001
Colored pencil and Prismacolor marker on photocopies
14 x 14 inches each
Courtesy of the Artist

**HALUK AKAKÇE** *Ryme Flexible*, 2000
Enamel paint and ink on museum board
16 x 20 inches
Private Collection, Courtesy Deitch Projects, New York

**INKA ESSENHIGH** *Getting Comfy*, 2002
Oil on panel
54 x 56 inches
Courtesy 303 Gallery, New York
and Victoria Miro Gallery, London

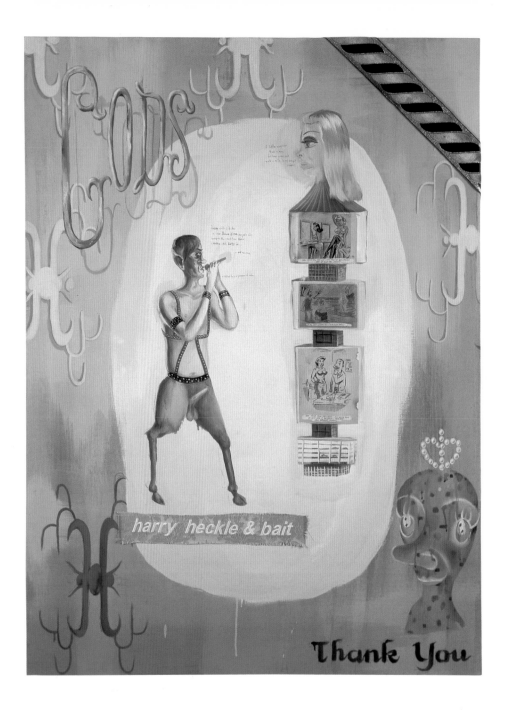

**GEORGANNE DEEN** *GODS (harry heckle & bait)*, 1996
Oil on canvas
52 x 38 inches
Collection of the Artist

**PAMELA JOSEPH**   *He attacked the Trainer*
From *The Adventures of Pussy Marshmallow,* 2001-2002
Watercolor and ink on paper
15 x 11 inches
Courtesy of the Artist

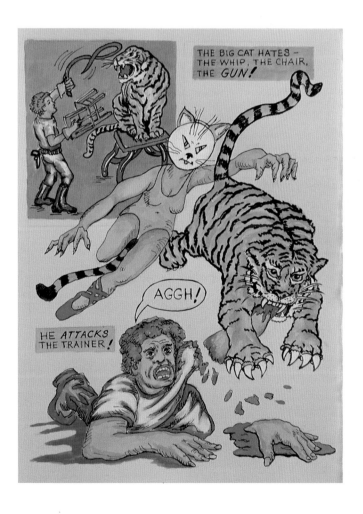

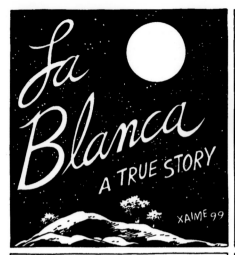

La Blanca
A TRUE STORY

XAIME 99

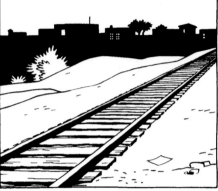

BACK IN THE THIRTIES, IN THE TOWN OF YSLETA, TEXAS STOOD AN OLD ADOBE HOUSE BUILT ALONG THE RAILROAD TRACKS.

FOR MANY YEARS STRANGE THINGS HAPPENED IN AND AROUND THE HOUSE. THE WALLS FREQUENTLY ECHOED WITH THE SOUND OF HUMAN TAPPING.

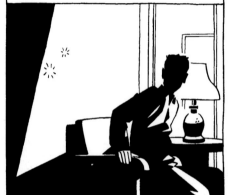

ONE MORNING ONE OF THE INHABITANTS OF THE HOUSE WOKE TO FIND HER BED TURNED TO FACE THE OPPOSITE SIDE OF THE ROOM. THERE WAS NO SIGN THAT ANYONE ELSE HAD ENTERED.

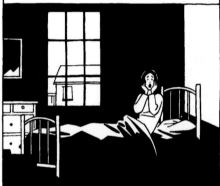

ONE DAY SOME KIDS PLAYING IN FRONT OF THE HOUSE HEARD A BELL-RINGING SOUND UNDER THE GROUND. IT SEEMED TO LEAD THEM TO THE RAILROAD TRACKS. THEY FOLLOWED THE SOUND ALONG THE TRACKS TILL IT DISAPPEARED.

ALL OF THESE ODD OCCURENCES WERE BLAMED ON A NEIGHBORHOOD GHOST THEY CALLED LA BLANCA, A BRIGHTLY LIT FIGURE OF A WOMAN HIDING HER FACE UNDER A SHAWL. THE CLICK OF HER HEELS COULD BE HEARD AS SHE WALKED.

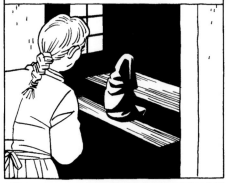

ONE NIGHT IN THE OLD HOUSE THE MOTHER THOUGHT SHE SAW HER DAUGHTER SITTING ALONE IN THE DARK. WHEN SHE CALLED OUT TO HER THE FIGURE, WHO WAS NOT HER DAUGHTER AT ALL, GOT UP AND SILENTLY WALKED INTO THE SHADOWS.

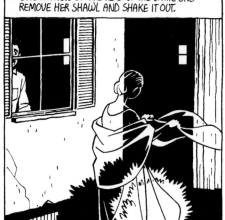

ONE WITNESS SWORE HE SAW THE WHITE ONE REMOVE HER SHAWL AND SHAKE IT OUT.

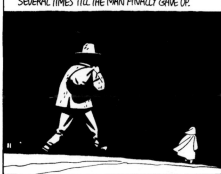

ONE NIGHT A MAN COMING HOME LATE FROM THE BARS SPOTTED THE APPARITION AND DECIDED TO FOLLOW HER TO ASK HER WHO SHE WAS. BUT ONCE HE CAUGHT UP TO HER SHE DISAPPEARED THEN RE-APPEARED SEVERAL FEET AHEAD. THIS WAS REPEATED SEVERAL TIMES TILL THE MAN FINALLY GAVE UP.

LA BLANCA'S DISPLAYS EVENTUALLY BECAME COMMONPLACE. AFTER EACH MANIFESTATION, WITNESSES WOULD GO BACK TO THEIR BUSINESS, ALBEIT WITH A NEW STORY TO TELL AT THE MARKET.

YEARS LATER, AFTER THE FAMILY HAD MOVED AWAY FROM THE HOUSE, IT WAS SAID THAT THE NEW OWNERS HAD THE STRANGE OCCURENCES INVESTIGATED.

THEY BROKE OPEN THE WALL WHERE THE TAPS ALWAYS ENDED AND FOUND A SMALL HIDDEN TREASURE OF CASH. AFTER THAT, LA BLANCA WAS NEVER HEARD FROM AGAIN.

THE END

A TIP OF THE HAT TO MOM HERNANDEZ FOR A GREAT TALE...

**JAIME HERNÁNDEZ** *La Blanca* (pages 1 & 2), 1999
Ink on paper
9 x 14 inches
Collection of Eric Reynolds, Seattle, WA

17

**KOJO GRIFFIN**  *Untitled*, 1999
Mixed media on wood
42 x 36 inches
Collection of Adrian M. Turner, New York
Photo: Guenther Knop, New York

**JASON JÄGEL** *Sword Swallower*, 2002
Gouache, ink and acrylic on paper
6 x 8 inches
Courtesy Richard Heller Gallery, Santa Monica, CA

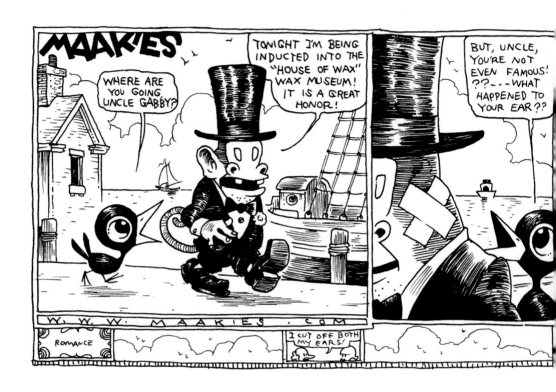

**TONY MILLIONARE** *Maakies,* 2001
Pen and ink on Bristol board
10 x 17 inches
Collection of the Artist

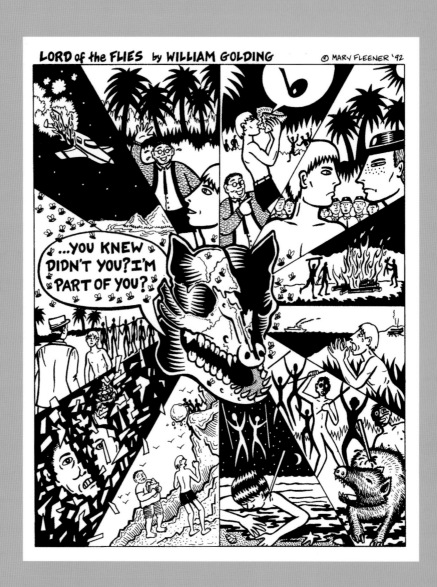

**MARY FLEENER**  *Lord of the Flies*, 1992
Ink on Bristol board
15 x 11 inches
Courtesy of the Artist

**LEE CHAPMAN** *Bingo*, 2002
Mixed media on canvas
24 x 24 inches
Courtesy of the Artist

**BOB BURDETTE** *The Temptation*, 2001
Acrylic on canvas
28 x 18 inches
Courtesy David Lusk Gallery, Memphis, TN

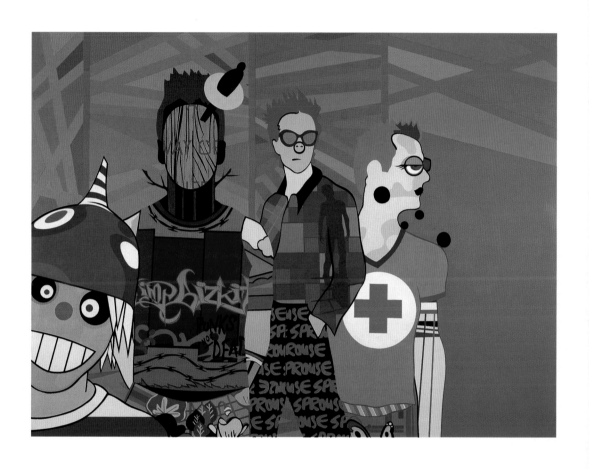

**MICHAEL BEVILACQUA**  *Disposable Teens*, 2001
Acrylic on canvas
30 x 40 inches
Collection of Kenneth L. Freed, Boston
Courtesy Fredericks Freiser Gallery, New York

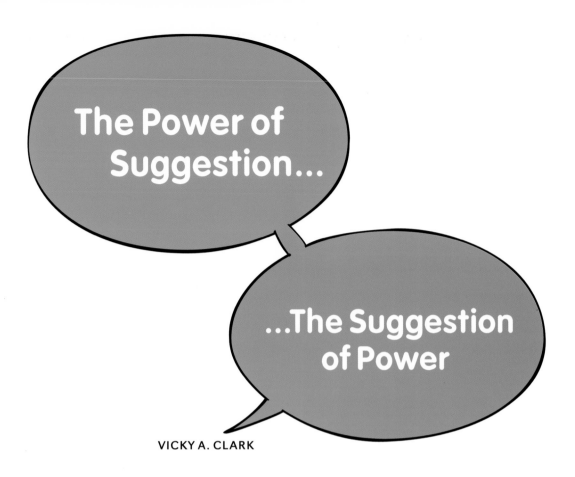

# The Power of Suggestion...

# ...The Suggestion of Power

**VICKY A. CLARK**

Every day I read the comics and cartoons in the local paper. As an adolescent, I identified with the characters in *Peanuts* or wanted to be the girls in *Apartment 3G*. Later, when I became politically active, I needed my daily fix of Oliphant, the political cartoonist, and *Doonesbury*—frequently found on the editorial page because its strong political content diverged from the gag-a-day or sequential comics. More recently I have seen myself in *Cathy* and my work environment in *Dilbert*, and I desperately miss *The Far Side*. I watch how new comics such as *The Boondocks*—by Aaron McGruder, dubbed the "equal opportunity offender" by the *New York Times Magazine*—are received, and I have even started reading *Spider-Man*. I chuckle, I sigh, I get pissed off, and I *am* surprised that postmodern ideas have infiltrated the everyday world of the funnies.

Comic and cartoon imagery is suddenly ubiquitous and exceedingly versatile: as the subject of Hollywood blockbusters and video games, in fashion from T-shirts to haute couture, in print and television advertising, on the emergency instruction cards in airplanes; even one of the latest boy bands—Gorillaz—is an animated group. Such imagery also appeals to artists wanting to communicate serious and often difficult ideas. The dramatically simplified style of comics creates a common and accessible language. It provides a vehicle to introduce serious issues in a palatable way, just as beautifully seductive images did in the 1990s.

Storytelling, one of the essential components of comics, has reappeared everywhere. Auto-biography and shared histories have played an increasingly important role in contemporary art because stories allow us to learn about ourselves and others. Experiments with the blurring of fact and fiction or with nonlinear narrative have become common in all storytelling mediums. Zines have proliferated, offering personal musings in an informal, throwaway format. As the world changes so, too, does the content, resulting in increasingly complex and disturbing stories. Comics have come of age, and they aren't just for kids anymore. Art and comics both question how to affect people and how to treat subjects that viewers don't expect to encounter in a work of art. These common approaches enhance the cross-pollination between art and popular culture that has char-acterized the last century.

## SUBLIMINAL INFLUENCES

Michael Jordan is a superstar and marketing phenomenon. It is easy to see why kids identify with the charismatic athlete; he is a flesh and blood superhero, and everyone wants to "be like Mike." He even shared star billing with Bugs Bunny in *Space Jam*. But Jordan is not the only role model who influences us; he is just one of the most visible. Athletes, supermodels, actors, rock stars, and even cartoon characters all play a role in constructing our sense of self, our identity.

The process of internalizing influences from popular culture operates on many levels. Charles Schulz remembered a friend telling him once that he had had a "Charlie Brown" day; Schulz imme-diately understood the sense of frustration and futility this reference implied. In *Zits*, a relatively new comic strip, an adolescent stretches out on the floor. He lifts up his shirt, surprised to find several word balloons under the surface of his skin. As he pokes them, they "speak" his mom's concerns ("how long will you be out?" etc.). Despite his efforts, her comments have definitely gotten under his skin.[1] The same process can happen to anyone who is influenced by a variety of sources, including family, peers, institutions, books, television, and films. We are all, more or less, subject to these sub-liminal influences.[2]

---

[1]   *Pittsburgh Post-Gazette*, April 14, 2002.

[2]   I offer an example from my own experience. Despite having read and absorbed feminist and postmodern theory, I fell under the spell of a popular television program. Although I had never wanted children, I found myself thinking about it in the 1990s. Why? Because I was watching Murphy Brown become a single mother. (A similar process partially explains why the young boy prays to Donald Duck in Gottfried Helnwein's *American Dream*.)

I don't need to go into the theory surrounding the construction of identity here. However, I have found a clear and concise explication in a PhD dissertation by Nancy French Lunning: "*Identity* refers most simply to the constructed set of character-istics by which an individual is known." "Identities are subject to the specificity of time and space: a mediating concept between external and internal considerations of the self." Quoting Madan Sarup, Lunning goes on to note that in mod-ernist terms, "all the dynamics (such as class, gender, 'race') operate simultaneously to produce a coherent, unified, fixed identity," whereas in postmodernist terms "identity is fabricated, constructed, in process... we have to consider both psy-chological and sociological factors." [Nancy French Lunning, *Comic Books: Sex and Death at the Edge of Modernity*, Ph.D. dissertation (Ann Arbor, MI: UMI, 2000), pp. 19, 24.]

The sporadic backlash against comics also confirms that they play a formative and influential role. Fredric Wertham's 1954 book *Seduction of the Innocent* decried the decline of written language skills and linked the reading of comics to juvenile delinquency.[3] His arguments fueled the debate in the Senate Subcommittee to Investigate Juvenile Delinquency, which looked at the comic book industry in its 1954 New York City hearings. The latter led to the comics code of 1954, which amounted to self-censorship (no authority figure as corrupt; no female sexualized; no criminal methods; no blood, gore, or violence; no unnecessary knife and gun play; no physical agony; no use of the words weird, crime, horror, or terror in the title).[4] Comic books were burned in the streets in the United States and confiscated at the border between East and West Germany before reunification, and recently cartoons have been criticized for being un-American in the post–September 11 ethos. In February 2002, for example, the White House expressed outrage over a cartoon in the *Concord Monitor* that depicted President Bush's new budget as an airplane headed toward the Twin Towers. Such criticism (and fear) is leveled at comic strips, comic books, cartoons, and graphic novels as well as at paintings, sculptures, installations, videos, and Internet artworks that attempt to bring up unpopular critical ideas. There must be a reason to fear the influence of these kinds of expression.

## PARALLEL TRACKS

Comics and art are, of course, related. Both use a visual language, many of the creators were educated in art departments or art schools, and both are produced in the same environment, subject to the same events and ideas. The Museum of Modern Art's 1990 exhibition *High and Low: Modern Art and Popular Culture* showed how comics influenced "fine art" in works by Miró, Guston, and Murray as well as in the wholesale appropriation of images on the part of Lichtenstein and Warhol. It is becoming increasingly popular for artists to create comic books, and many have worked as cartoonists. In reverse, cartoonists frequently borrow styles and techniques from artists and also use the art world as subject matter. But the relationship is, quite obviously, more complex than that. Setting aside the decades-old, and mostly boring, argument that different values are assigned to popular culture and to art, we now understand that all methods of expression are subject to the issues and concerns of a particular time and place. As we struggle to come to terms with our world—especially since the postwar period with rapid changes in terms of civil, women's, gay, and lesbian rights; science, technology, and the environment; television, films, and the Internet; AIDS, drugs, and cloning; and religious apathy, scandal, and zealots—those involved in comics and the visual arts have struggled with the same issues.

Art and comics have been on parallel tracks. Comics have moved from a sweatshop, assembly-line environment through the idiosyncratic underground into a new popularity, carried by direct marketing and diverse, relevant content. They have also become self-referential, usually a sign of a mature cultural form. Recasting superheroes, born earlier in the century when Americans believed

in the difference between good and evil, to add relevance and believability is similar to deconstruction efforts among visual artists. Both camps have explored identity, history, and the common assumptions that color our histories.

### FROM SUPERHERO TO LESBIAN TERRORIST

Comparing the trajectory of the superhero, perhaps comics' most influential contribution to the cultural landscape, with that of the voice of the other in contemporary art also reveals striking parallels. Superman, born in 1934 (though not published until 1939) from the pens of Jerry Siegal and Joe Shuster, was a hero for his time, a conscientious, zealous protector of law and order, a man who used his superhuman powers to restore order and maintain the status quo. Designed to uphold American values in the time of world wars and the Great Depression, this public hero also had personal links to his creator. Siegal imagined an alterego who was everything he was not. Clark Kent was a wimp until he donned the Superman costume, wore glasses that became unnecessary with his double's X-ray vision, and had no luck with girls, who, however, swooned in the presence of Superman. Like heroes in John Ford movies and John Steinbeck novels, Superman was the champion of the oppressed, fighting for the common man against the evils of greed and injustice.[5] But Superman was not alone. Batman, motivated by the brutal slaying of his parents, also fought crime, and Wonder Woman, the Amazon based on the model of progressive social work, took up the cause of women and children. Their respective personality traits developed over the years in many comic books and movies, becoming part of the code of the superhero that provided youngsters (predominantly boys) with models of success, responsibility, and acceptability, a picture of what would be expected of them.

These underwear heroes were the epitome of masculinity. The superheroes illustrated the proper response of the individual to use power for the good of the group, and their exploits hinted that anyone could become a better person. Little boys put on this superhuman identity with Superman's cape and dreamed of his conquests as they slept on Superman sheets. They yearned to overcome their own flaws to become popular, just as Siegel created his "better half" to compensate for his perceived failings. Needless to say, there was little here for young girls except a picture of their future boyfriends and husbands.

---

3   This discourse has continued in the last half century, moving on to posit the detrimental effects of rock music, violence, and sex in movies and, now, video games as a means for instituting self-censorship codes.

4   See Robert Harvey, *Art of the Comic Book: An Aesthetic History* (Jackson: University Press of Mississippi, 1996), p. 43. Scott McCloud uses different words to describe the code's prohibitions: no gore, sex, sadism, no challenges to established authority, no unique details of crime, no hints of illicit relations or the condoning of divorce, no physical afflictions, no sexual perversions. [See McCloud, *Reinventing Comics: How Imagination and Technology Are Revolutionizing an Art Form* (New York: HarperPerennial, 2001), p. 87.]

5   See Bradford W. Wright, *Comic Book Nation: The Transformation of Youth Culture in America* (Baltimore: The Johns Hopkins University Press, 2001), p. 11.

Superman represented the Horatio Alger–like vision of the American dream. Michael Chabon's engrossing novel *The Amazing Adventures of Kavalier and Clay* (2001) offers a vivid portrait of the personal yearnings of his outsider protagonists who, struggling to get by in the ethnic ghetto of New York City, invent their hero the Escapist. Both boys are poor, Jewish immigrants, Kavalier having escaped the dangers in Europe. They are on the outside, looking in, trying to live the American dream which they, like Siegel, create in the form of a superhero who reinforces American values.[6] These were the romanticized yet real heroes of adolescent boys. They helped boys form their identities, especially when navigating the slippery slopes of masculinity.[7]

Our conception of the American dream has changed and so have identity issues. Now issues of masculinity are hopelessly convoluted and complex. The underground and alternative scene as well as direct marketing brought a more diverse content to an adult audience and shifted the focus from escapism to introspection, as Harvey Pekar explained: "I want to write literature that pushes people into their lives rather than helping people escape from them."[8] The new comics broke the mold of the superhero, and other protagonists, by introducing more personal, ambiguous, political, sexually explicit themes and issues. Robert Crumb, canonized for his wicked portrayals, changed the landscape forever when he "[dipped] his pen into your subconscious and [put] it right on the page for you to see," warts and all.[9] Everything became fair game, including sex, drugs, and rock 'n' roll in the rebellious 1960s and 1970s. *Mad*, *Raw*, *Zap*, and *Bijou Funnies* were cult offerings, paving the way for comics that included more work by women, such as *Wimmins Comix* and *Tits 'n' Clits*.

> The superhero had to change. Denny O'Neil, a reporter turned writer who collaborated with artist Neal Adams on the *Green Lantern* asked: "Could we dramatize the real-life issues that tormented the country in the context of superheroics? Could we fashion stories about drug addiction, environmental destruction, corporate rapacity, cults, racism, poverty, bigotry—the whole catalogue of national discontent that energized the era—and still deliver the heroic fantasy that people bought comic books for?"[10] He answered in the affirmative with the addition of the Green Arrow, the more liberal sidekick who continuously challenged the conservative values of the Green Lantern.

Frank Miller's *Batman: The Dark Knight Returns* (1986) goes from the global to the personal by reintroducing the hero as a multifaceted figure who works out identity issues. In *Watchmen* (1986) by Alan Moore and Dave Gibbons, the standard, old-fashioned black-and-white simplicity of good versus evil has been replaced by a more complex set of issues. Aging superheroes come out of retirement to save a world they don't recognize anymore. They are confused not only by the world, but by themselves. Others followed, such as Wolverine, "a Dirty Harry with a Canadian accent" who owes much to the antiwar sentiments of the 1970s, and the superhero became an antihero, an aberration in the everyday world. There were a wider variety of protagonists whose stories more closely reflected a growing diversity in society.

Much of this recasting and rewriting follows a kind of "wink, wink" postmodern deconstruction of the superhero: muscular men in tights, faces covered with masks, close male friends. As one critic wrote, "If I want Batman and Robin to be gay, they are." A new reading of the construction of masculinity and role models occurs, making the undercurrents obvious and uncovering what lies just beneath the surface. Graphic novelists, including a growing number of women, introduce a diverse array of characters: Phoebe Gloeckner tells of "childhood cruelty, family dysfunction, and queasy sex" in *A Child's Life and Other Stories*[11]; Diane DiMassa creates a hotheaded paisan who is a homicidal lesbian terrorist; Alan Moore mimics English tabloids in depicting AIDS victims in concentration camps during the Thatcherite era; and Chester Brown speaks through Ed The Happy Clown, who has long and involved discussions with his penis. There have even been comic books starring Jeffrey Dahmer and Ted Bundy.

> **The dramatically simplified style of comics creates a common and accessible language. It provides a vehicle to introduce serious issues in a palatable way, just as beautifully seductive images did in the 1990s.**

Recently, the role and the characteristics of the superhero have been excavated and challenged to an even greater degree. Melissa Marks has created her own superhero, Volitia, who is involved in a series of adventures. Volitia is not like Wonder Woman, who was fashioned from stereotyped conventions. Instead, Marks uses an abstracted, amorphous form, comparing Volitia to water, which is always in a state of flux. This allows Volitia to change as Marks' series progresses,

---

6   Chabon's book is a wonderful read, in the vein of American novels such as those by Sherwood Anderson. Reading Chabon's story at the same time as nonfiction accounts of the history and meaning of comics raises the question of how best to understand a cultural form and a previous era. As fact and fiction merge, sometimes it seems as though novels reveal as much as so-called factual accounts.

7   An interesting side note is raised by Art Spiegelman in a recent issue of the *New Yorker*. He points out that many of the early cartoonists were Jews, placing them in the context of the Jewish intelligentsia in New York in the first half of the century. This certainly affects the identity issues found in their works. [See Spiegelman, "Comix 101: Ballbuster, Bernard Krigstein's Life between the Panels," *New Yorker*, July 22, 2002, pp. 70-74.]

8   Quoted in Harvey, *Art of the Comic Book*, p. 235.

9   Phil Seuling, quoted in ibid., p. 213.

10   Quoted in ibid., pp. 222-3.

11   Quoted in Andi Zeisler and Lisa Miya-Jerris, "Drawn from Memory: An Interview with Phoebe Gloeckner, Artist, Storyteller, Freaky Mama," in *Bitch: Feminist Response to Pop Culture* 3, no. 3 (October 31, 1998), p. 38.

reinforcing our sense that our personalities are fluid, continually redefined as we are exposed to new experiences and ideas. At the same time, the future has arrived, and as in science fiction, changing technology plays a greater role. Artists such as Inka Essenhigh and Haluk Akakçe bring the cyborg into the realm of the superhero, giving us yet another model of hybridity that goes beyond the old-fashioned, one-dimensional characters.

Similar developments in contemporary art are so well known that the parallel can be stated quite simply. Starting with the "We Are Here" school of Judy Chicago and company in the 1970s, artists stormed the citadel of modern art demanding to be seen—and showing much more than usual in the process. After the initial euphoria came the more theoretical side of postmodernism, as evidenced in the deconstructionist work of Cindy Sherman and Gary Simmons, among many others, who pointed out how stereotypical role models—many of which are found in comics—affect how we see ourselves. The frustration with the insiderisms and the one-liners of deconstruction led to a complex, multilayered, and at times ambiguous approach in which the viewer began to "participate" in the creation of the meaning of the work. Identity discussions shifted to the concept of the hybrid, showing how identity is formed from many influences and is constantly changing. Books such as *Routes: Travel and Translation in the Late Twentieth Century*, by anthropologist James Clifford, charted the movement of ideas and forms in a transient culture, showing how hybrid forms and identities have become the norm. Yasumasa Morimura, for example, places himself in the center of his cultural influences by morphing himself with figures in Old Master paintings, playing with ideas of East/West, Asian/Caucasian, male/female, straight/gay. Though we are influenced by stereotypical roles, we actually have "multiple personalities."

> **Comics have come of age, and they aren't just for kids anymore. Art and comics both question how to affect people and how to treat subjects that viewers don't expect to encounter in a work of art.**

Clifford's model of cultural transformation and hybridity helps us to understand the convergence of art and comics. Where there once were universal heroes and ideas, there now are personalized and complicated voices. Where we once sought separation between art and comics, we now embrace connections. The term "hybrid" can be applied to the makers and to the readers of hybrid works, which combine art and comics (hybrids themselves, combining art and literature, images and words) in creative and innovative ways.

### IDENTITY CONSTRUCTION AND DECONSTRUCTION

Identity issues have played a crucial role in postmodern art, leading the charge against the status quo both in and out of the art world. Artists have contributed to the discourse of how identity is formed by showing that widespread dissemination of imagery can influence us, by deconstructing stereotypical imagery, and by creating their own narratives to shift and abolish the narrow bounds of existing imagery and role models.

Comics have gone from being "bright, colorful magazines filled with bad art, stupid stories, and guys in tights" to become vehicles for the investigation of identity ("We don't just observe the cartoon, we become it").[12] Even people who are not interested in identity issues can understand that the recently released *Spider-Man* movie is more about the hero working out his adolescent issues and getting the girl than about saving the world, and that the overcommercialization of Disney characters has altered their impact forever. It is even debatable now whether Mickey Mouse and friends are real or imaginary, in a Baudrillardian sense. As Takashi Murakami has said about Japanese *manga* and *anime*, "I found them real because I grew up with them."[13] Real or imaginary, cartoon characters serve to construct and validate identity.

Daniel Clowes' *Ghost World* features Enid, an awkward young woman, played by Thora Birch in the movie adaptation with a perfect deadpan style that can be compared to the flat and generalized drawing style of comics. She is searching for her place in the world, which is, as director Terry Zwigoff says, "rapidly turning into a big consumer theme park, a monoculture without anything authentic remaining. She's trying to connect with something truthful in this culture that's basically designed to just sell you things."[14]

In a review of Peregrine Honig's work, critic D. K. Row wrote:

What's a young woman to think nowadays? On the one hand you have virtually every print magazine, commercial advertisement, television series, and movie subliminally projecting the ideal of Modern Woman as a fabrication of great cheekbones, busty physical perfection, and manly attitudes toward casual sex and professional options. Yet, on the other hand, you have the likes of writer Susan Faludi (*Backlash*), whose simplified rhetoric of victimization generalizes that all women (and men, in her latest book on victim analysis, *Stiffed*) have gotten A Raw Deal: We're All Victims of These Shallow and Unfair Times. Confused is the answer....[15]

12   Scott McCloud, *Understanding Comics* (New York: Kitchen Sink Press for HarperPerennial, 1993), pp. 2, 36.

13   Quoted in Kay Itoi, "Pop Goes the Artist," *Newsweek* (summer 2001, special issue), p. 86.

14   Quoted in David Thomson, "A Director Who Likes to Sit Alone in the Dark," *New York Times*, July 22, 2001, sec. A, p. 19.

15   D. K. Row, "Pretty in Pink," *The Oregonian*, October 15, 1999.

Our identities are constantly being constituted and reconstituted as we absorb and process influences from a variety of sources. This can be difficult to understand and/or acknowledge, but we are, at various times, more or less cognizant of what influences us. This process, which is at the heart of *Comic Release*, starts as soon as we make an appearance in this world.

Childhood is a time of dreams, a time to play dress-up and try on various costumes and roles. The world seems full of possibilities. But how do you answer the question: What do you want to be when you grow up? Your world provides your potential answers; you look around you, drawing on what you experience in your family, among your friends, at school and/or church, and in books, videogames, and movies. You read the same comic books featured in *Classic 32* by Leslie Lew, living vicariously through the exploits and absorbing the influence of Nancy, Dick Tracy, Popeye, Brenda Starr, and Blondie.[16] You dream of, play with, and pretend to be superheroes. You even dress up in your hero's costume, and you sometimes sleep under something like Mark Newport's *Freedom Quilt*, where the imagery from Batman and company literally covers the child.[17] You play video and computer games, perfectly at ease with the type of oddball characters depicted in Chris Finley's funhouse paintings.[18]

And then there are the Disney characters. They are everywhere, and they are controlled completely by Disney; the company sues those who use the imagery without consent and sets strict regulations for the people who portray the characters in Disney theme parks. Each character is copyrighted, as Julia Morrisroe reveals in her incised drywall drawing. By including Disney's required copyright credit on every conceivable surface, even on Pooh's tree, she emphasizes the extent of the company's control of the imagery. At the same time, by incising the familiar figures and their attributes into the surface of the wall, she references the subtle influences that become internalized by a child finding his or her way in the world. Disney's success has led to many imitators; every major movie makes products available at McDonald's or Burger King, every cartoon character gets a line of toys, and everyone wants to be an action hero. Ryan Humphrey uses many of these action figures in his self-referencing installation *Ultra Geek (Episode I)*, which one critic has called a "boy's wet dream." It is tempting to see marketing as the driving force of our identities.[19]

Now, however, we look at these images with eyes wide open. At times, there is nostalgia for seemingly simpler times, for the time of childhood innocence before reality knocks. But there is also comprehension of the messages inherent in these characters. Robert Karstadt, who grew up dreaming about the superheroes depicted in his *Hall of Heroes*, now recognizes the manipulative undertones in his childhood icons.[20] Meredith Allen hints at other underlying concerns with her popsicles photographed in landscape settings. The melting Snoopy and Pokemon evoke ideas about the messy, oozing body, consumer culture with its built-in obsolescence and darker thoughts of bad things happening to children.[21] Philip Knoll looks under Superman's cape to un(re)cover the

muscles and flesh of the male superhero, who here plays the part of a gorgeous (gay?) male. Genitals are added to desexed favorite childhood characters: Nadín Ospina adds a penis to Mickey Mouse and Karen Finley goes even further by depicting Pooh and his friends engaging in S&M.[22] John Bankston, Kara Walker, Michael Ray Charles, and Peter Williams use fairy tales and cartoon imagery to show how racist stereotypes become part of children's visual vocabularies, affecting their self-images.

As Dorothy says in *The Wizard of Oz*: "We aren't in Kansas anymore." In the same manner that she discovers a new world where identity issues play out as she travels the Yellow Brick Road, we have moved beyond the world of black-and-white, cardboard characters to see ourselves in more complicated ways. As the superheroes have become more complex so, too, has our comprehension of our world. We see ourselves as thinking, changing, neurotic, funny creatures that are amalgams of characteristics gathered from popular culture, our families, our institutions, and our shrinks. We can laugh at ourselves and our issues, and we can use comic imagery to explore both, to reveal ourselves in all our complexity.

One site of identity contention is our body, and our obsessions about it are the subject of reams of scholarship, talk shows, new health and appearance enhancing industries, and a whole faction in contemporary art (think red oozing orifices from Judy Chicago, Cindy Sherman's cast of characters, Catherine Opie's dykes, Andres Serrano's sexual couplings, Robert Mapplethorpe, Sally Mann, and on and on). Comics feature stereotypes: men with bodybuilder physiques and women with

16  An additional aspect to this work by Lew is that the comic characters are placed on postage stamps, a form of mainstream validation in the United States.

17  Newport's piece also interrogates gender roles as he uses a form associated with "women's work" to create images of *hyper*-masculinity.

18  This sense of play does not desert us when we grow up. Adults also wear cartoony T-shirts or carry sparkling purses in the shape of Minnie Mouse or wear bracelets like the one designed by ROY, which shows Godzilla in a fez looming over the stereotypical city portrayed in the comics.

19  How else do you account for at least two women who are having plastic surgery to make themselves into living Barbies?

20  Robert sent me a copy of a paper titled "Witness the Dark Angel: Batman, an American Fascist Icon," in which he deconstructs Batman.

21  Though I myself tend to read a lot into images, I do find that Carol Schwarzman goes a bit far in a review on wburg.com in which she writes: "*Pokemon*, a spooky, impish apparition of the cartoon character because of the melting process verges on the disgusting. It's wonderful to remember that this synthetic, drippy dessert is something to be eaten. Like mythic Saturn devouring his offspring out of jealousy, or the Titans devouring Zagreus the baby (whose heart is later transformed into Dionysus by Athena), *Pokemon* speaks of cannibalism to scare as well as to make mock of fears of death and putrefaction. Fantasies of goring of children and adults contain and control such fears, and are further transformed in Christian themes of transubstantiation." [Carol Schwarzman, "Meredith Allen: Recent Photographs," WBURG Quarterly Online Review 2, no. 1 (autumn 2001), <www.wburg.com/0201/index.html>.]

22  Pooh has been the subject of two essay compilations by Frederick Crews: *The Pooh Perplex* and *Postmodern Pooh*.

supermodel figures. But that typing is ripe for parody and irony. Angela Wyman, for example, distorts the female body to the point where it is all boobs, supported on an emaciated body as if she is reflected in a male-engineered funhouse mirror. Wyman can look at our obsessions with a sense of humor, moving beyond the anger of early feminists. Juliette Borda's quirky drawings reveal the insecurities we have about our bodies and ourselves, focusing on acne, body shape, and/or facial hair in her cartoony illustrations, which encourage us to laugh at our imperfections. Christa Donner produces zines such as *For Ladies and Their Friends*. The cover of "The Hair Issue" is filled with examples of our hair obsessions: braids, dreads, facial hair, shaving, and going bald. Jin Ham, a Korean artist, gives us psychosomatic figures that react to our fear of germs and illness. He makes tiny figures out of detritus and, like a playwright, describes them in a variation on the word/image duality of comics. One of his stars is Pill boy: "born in a pill/a child always being intoxicated by medicine pills/ metaphor for the people of today who always feel sick/always taking pills when they feel sick and carrying pill case/favorite: food as medicine/ hates: he hates sports, always want to be cured by medicines/ skill: swallowing pills gobbling up a whole box of pills/ frequent saying: I feel sick."

Dealing with the body in a slightly different way are Pamela Joseph, Peregrine Honig, Amy Sillman, and Sally French. Joseph revels in the bad girl persona in her adventures of Pussy Marshmallow, in which, naturally, she emphasizes female sexuality and power. Honig, in her *Awfulbet*, deals with the darker results of our preoccupation with our bodies as well as preconceptions of how they should look. Her delicate drawings of girls on paper bags, a mundane throwaway object, present an alphabet based on body issues: "E is for Emma throwing up dinner," "F is for Faye who prayed to be thinner," or, in her related *Ovulet* series, "F is Fiona drunkenly raped" and "O is Olivia who begged him to stop." The contrast between the simplicity of the drawings of fragile girls and the directness of the text delivers a powerful punch. Sillman combines several incidents in the space of one painting. In a particularly strong section of *For Bruno Schulz* we see a prone woman being attended to by a bird who seems to be sewing up her abdomen. Is this a scene of abuse, of surgery—perhaps a hysterectomy—or is it a reference to the Greek myth of Prometheus in which a bird pecks at him on a daily basis? Her meandering tale is a stream of consciousness that evokes a host of associations. French's work follows a woman through the later stages in her life. In addition to the physical changes that come with menopause, women frequently face lifestyle changes: children leaving home, marriages in which couples are now comfortable friends or divorced, and bodies that are breaking down. Her smart choice of surrogates includes Olive Oyl, as a figure of repressed sexuality, and a duck that experiences the "passages" of a woman's life. Olive Oyl, drawn as the skinny, unattractive woman in Popeye's life, is a keen example of a woman's floundering self-image as she ages, but the question is whether Olive is truly repressed or whether that is merely how she is perceived by Popeye or by her creator. French hints that the answer is the latter, as her bulkier, abstracted Olive vomits a swarm of bees that represent cultural misconceptions. The duck,

a funny little bird that waddles, represents the awkwardness that frequently accompanies one's coming to terms with a changing life.

Juliette Borda, Nicole Eisenman, and Georganne Deen go beyond the individual to deal with the trials and tribulations involved in relating to others. They move through various stages of inter-action, from insecurity when meeting new people to the full flush of love or friendship through to the end of the relationship. These little stories can be compared to those in Julie Doucet's graphic novel *Dirty Plotte*, which chronicles the details of everyday life, ranging from tampon use to sexual rela-tionships, or the growing number of zines in which kids work out their anxieties and dreams. Our daily lives, from boring details to major events, provide fodder for many artists, including Marcel Dzama and Neil Farber, who mine the minutia of our lives, searching for meaning. Dzama and Farber are like naughty schoolboys having fun yet revealing disturbing incidents occurring beneath the surface, whereas Michael Bevilacqua presents the marginalized in our culture, the "disposed teens" hanging out in the streets with their "look at me" attitude. The stories presented in all of this work range from the type of uplifting accounts we might hear on *Oprah* to the tirades of dysfunc-tional crazies who are featured on *Jerry Springer*. We might not know how to solve our problems, but we certainly know how to express them.

Sean Landers has been compared to Howard Stern, whose rantings can be seen as an oral zine. Landers' earlier work consisted of reams of lined yellow paper on gallery walls on which he shared his desires, his experiences, his obsessions, his problems, virtually producing a zine on site. More recently, he has put those musings in the backgrounds of paintings that feature animals or carica-tures of people such as Truman Capote. In the process he takes the visual/verbal combination so typical of comics and graphic novels in a new direction, creating an aesthetic push/pull action between the text and the image.

## TELLING STORIES

Increasing recognition of difference and diversity requires new ways of communication, and that is another reason why comics have become so popular in the art world. The ability to move beyond a single image into a narrative, even if it is implied, allows artists to share histories. As artists adopt the narrative tools used by comics artists and graphic novelists, they take advan-tage of the verbal/visual union and tension. "Comic art, after all, is a potentially complex narrative instrument, offering potent forms of visual-verbal synergy in which confused and even conflicting points of view can be entertained all at once."[23] Hence, the interest in new narrative modes, including nonsequential and nonlinear storytelling, that inevitably refuse closure, inviting the

[23]  Charles William Hartfield, *Graphic Interventions: Form and Argument in Contemporary Comics*, Ph.D. dissertation (Ann Arbor, MI: UMI, 1991), p. 277.

viewer/reader to complete the narrative in his or her own way. This postmodern strategy reacts against the timelessness and the authority of modern art.

In comic strips and books, the space between the panels represents shifts in time and/or place, gaps that the reader fills in to complete his or her reading of the story. This active form of reading is described by Scott McCloud: "[The gutter] is host to much of the magic and mystery that are at the very heart of comics. Here in the limbo of the gutter, human imagination takes two separate images and transforms them into a single idea."[24] Since we strive toward a unified reality, we connect the separated moments into a continuous narrative, or as David Carrier writes, "we expect the world to fit our preconceived stable categories, and so what falls in between is easily felt, depending upon the temperament and politics, to be either exciting, or menacing."[25] These pauses allow artists to insinuate action and ideas offstage—a technique common in Greek drama to shield the audience from disturbing or offensive material—as well as to force the reader to fill in the blanks. This strategy can be found in David Salle's use of different spatial planes to present fragmented ideas; in the interactive work of Bill Seaman, where viewers manipulate a mouse to restructure a series of words and images, creating new and interesting juxtapositions; or in Laylah Ali's sequential narratives that develop across more than one drawing, yet with an ambiguity in the action that can confuse the typical left-to-right reading. In all such efforts, the viewer is left to interpret the story, to help construct the meaning, to provide his or her personal take on the work.

This desire to encourage, if not coerce, viewers out of their ordinary preconceptions is a trait shared by artists in both camps. Chris Ware experiments with disjunctive verbal/visual interplay in his *Thrilling Adventure Stories* by liberating the narrative; his text runs from thought balloons to captions and even to banners and signs. He also subverts standard conventions, such as the use of heavy type for dramatic moments. He disorients the reader's assumptions about what is true and what is imagined in a technique that is similar to channel surfing with a remote control.

Another disorienting technique is the blurring of fact and fiction. Art Spiegelman bravely took on the Holocaust in *Maus*, one of the earliest and most influential graphic novels. Moving effortlessly between past and present, dreams and interviews, family life and memories, photographs and drawings, Spiegelman grounded his journey into the unknowable in the everyday details of family life. His process of self-discovery travels through the fruits of his and his father's imaginations, leading to what we want to believe happened more than to what really happened. His continual process of reevaluation throughout the graphic novel is a search for self-understanding and underscores his affinity with postmodern theory's emphasis on shifting and multiple realities as well as its comfort with ambiguity.

His work can stand side by side with that of Anselm Kiefer, Christian Boltanski, and Sigmar Polke, artists who question our understanding of the history of the world wars and the Holocaust. Boltanski's work, in particular, has many parallels. Like Spiegelman, Boltanski conflates fact and

fiction by manipulating pseudo-documentary photography to create an "archive" of Holocaust victims. His enlarged and grainy photographs as well as his "artifacts" evoke an authenticity, tied to our memories of what we believe to have happened. Boltanski encourages viewers to think about history: how it is constructed, and how it is presented. The truth in his presentation is just as fictive as the remembrances of Spiegelman's father. Both artists reveal the subjective nature of history, memory, and identity. Joe Sacco's exploration of Bosnia, the books of images coming out related to 9/11, and new productions about Afghanistan all follow in this vein as they attempt to come to some understanding of what seems incomprehensible to most of us and yet shapes our views about the world and ourselves.

This questioning and disorientation also finds expression in nonlinear storytelling. Scott McCloud showed how the page could be subdivided in a way that denies the typical left to right, top to bottom reading in order to further certain aspects of storytelling. It can allow an artist to include dramatic shifts in the timeframe or the location of the story. Gilbert Hernández uses this approach in his extended work *Heartbreak Soup*. He manages to convey the simultaneity of village life by sliding between the past and the present and by populating Palomar, a small village in Mexico, with a diverse and changing cast of characters. Examining the role of the individual within the community, he explains his characters' actions by filling in previously unknown information about their histories. His layered, nonlinear storytelling eventually became too complex for most readers, and even Hernández himself abandoned this challenging format in later work.

Many visual artists make use of a fragmented presentation, implying a narrative that the reader/viewer must construct. Christian Schumann, Cisco Jiménez, Lee Chapman, Brad Kahlhamer, Barry McGee, and Chris Johanson all adopt the potential of comics' fragmentation, to a greater or lesser degree, in their allover, nonhierarchical works. The surfaces of their pieces look a lot like graffiti —the cultural form that characterized the battle between chaos and order, especially in the 1980s as landlords and politicians and artists danced around one another over this urban form of identification—as they bring the energy of the street and the visual overload of contemporary life to their work. Their challenge to make sense of the cacophony is one we face daily in our image-laden world.

## SO WHAT DOES IT ALL MEAN?

How do we approach the work in this show? By grouping the work under a broad theme, like identity politics, we have implied an agenda on the part of the artists that is not even intended in some cases. But that is only part of the story. Comics provide a versatile vehicle with many attractions, as does contemporary art. We have implied an equality among all of the producers, whether they are writers, illustrators, artists, or some combination thereof. This makes writing

24   McCloud, *Understanding Comics*, p. 66.

25   David Carrier, *The Aesthetics of Comics* (University Park: The Pennsylvania State University Press, 2000), pp. 70–71.

about the work difficult because we need new terms for describing these artists to replace traditional monikers such as illustrator, writer, inker, graphic novelist, painter, etc. Whenever vocabulary starts to seem outmoded, it suggests that a new paradigm is needed.

It is also interesting to ask if the use of comic imagery and the growth of graphic novels and zines has affected our perception of ourselves and others, or whether the work is still dismissed too easily. Much of the work does seek to bring new voices and images to the forefront and even to effect social change. In fact, when reading about the history of comics, I sometimes felt that I was reading about the history of contemporary art. In Robert Harvey's history of comics, for example, he lists the subjects available for satire:

romantic visions of superheroism
pop culture ideal of macho violence
demeaning nature of most jobs
conventions of gothic romance novels
tendency to see evil in anything we don't understand
fanatic religious cults
show business aura of politics
inherent dishonesty in political life
influence of special interests on politics
any custom and/or facet of social interaction
deleterious effects on the individual of ruling opinions of society/establishment.[26]

This could be a list of topics for any postmodern visual artist. In the same way that comics graduated from the men-in-tights stereotype, artists moved beyond the modernist ideal of an abstract, universal truth. Both have sought new strategies to break away from our preconceived ways of operating and thinking, especially about who and what is represented. But do they have any effect?

Many creators ask that very question themselves. In the 1970s, writer Steve Gerber introduced Howard the Duck. In one serial story, Howard tries to find meaning in his life, his true self, and a method of self-expression. He reflects on the conundrum that socialization usually means indoctrination, but that refusal to adapt leads to disillusionment. In a mental institution, he fights for his sanity, balancing the need to conform with the desire to be an individual, recognizing the relativity of facts and truth in the process. In the end, he rationalizes that, "Life's too far in the future to think about. Right now, I could use a good cigar." As Robert Harvey suggests, "the implication is that metaphysical questions about the nature of individual existence in the social world are relatively unimportant. What's more, they only breed hang-ups. More important for personal well-being is engagement—meeting the world and living it."[27]

Howard's dilemma is at the heart of critical work about identity. Gilbert Hernández ponders the same problem through his supremely aware character Humberto, an artist who questions the rela-

tionship between art with an agenda and social activism. Do his images become objects of consumption or catalysts for insight and understanding? His conclusion is in line with Susan Sontag's dictum: "The person who intervenes cannot record; the person who is recording cannot intervene." She implies that photographs are not "windows" on the world so much as "screens" that shield us from direct contact with the world.[28] The same could be argued for the use of humor and comic imagery in challenging artworks and graphic novels. The question itself is not new. The meaning of images has always occupied us. David Carrier begins his study of comics with a question posed by Ernst Gombrich about the process of "finding out what role the image may play in the household of the mind."[29] Though many do not believe that these works can effect social change, many others believe in the power of images and words to intervene in and change our cultural histories and beliefs.

> **We can laugh at ourselves and our issues, and we can use comic imagery to explore both, to reveal ourselves in all our complexity.**

It seems that comics have many characteristics that would work toward that end. They are a hybrid form, marrying images and words in a sequential narrative, making it hard to place them in any narrow category. Identity politics have also revealed that identity is not as simple as it appears, and that we are all hybrids made up of a combination of factors, including genetics and biology, environment and experiences. Therefore, comics and identity make a powerful pair, allowing artists to blur and to break through boundaries, to be comfortable with change, to reveal that binary oppositions only exist in abstract thought and that we are faced with multiple realities, multiple truths, multiple views, and complex interrelationships among all of the above. These shifting relationships have pleasantly complicated the question of what is art, making it easier for us to see that comics can live quite nicely in the realm of art, or vice versa. But at a more basic level, these works reveal how we fashion ourselves through the stories we tell. In a way, we have penetrated the power of suggestion to internalize instead the suggestion of power.

26   Harvey, *Art of the Comic Book*, p. 225.

27   Ibid., p. 228.

28   Hartfield, *Graphic Interventions*, p. 181.

29   See Carrier, *The Aesthetics of Comics*, p. 2.

Perhaps we can return to the superhero one last time. Jack Coles introduced Plastic Man in 1941. His power was based on his ability to mold his body into any shape to fit any situation, to morph himself into anything and anyone. The same transformative ability of art, comics, graphic novels, and zines—which continuously morph into new and hybrid forms—can reveal to us new aspects of ourselves and of our world.

**VICKY A. CLARK**, is an independent curator, art critic for the Pittsburgh *City Paper*, and Adjunct Associate Professor of Art at Carnegie Mellon University. Dr. Clark founded the Forum Gallery at the Carnegie Museum of Art, where she organized *Barbara Bloom*, *Meg Cranston*, *Jeff Wall*, and *After the Wall: Art from Berlin*. She also edited and contributed to a book on the history of the museum's key exhibition: *International Encounters: The Carnegie International and Contemporary Art, 1896-1996*. As curator at the Pittsburgh Center for the Arts, Clark curated exhibitions including *Recycling Art History*, *Digitial Traces: Navigating Interactive Domains*, *The Fact Show: conceptual art today*, and two versions of the *Pittsburgh Biennial*. She has contributed articles on contemporary art, artists, and issues to international magazines and catalogues.

Vicky A. Clark would like to thank Joseph Folino Gallo and Gretchen Zellner who continued to work on the project after we left the Center as well as David Madden, Robert Raczka, George Heidekat, William Stover, Charles Biddle, Sarah Loyd, and others who contributed names, leads, and information. Thanks as well to Karen Slevin and Natalie Taaffe for their early support.

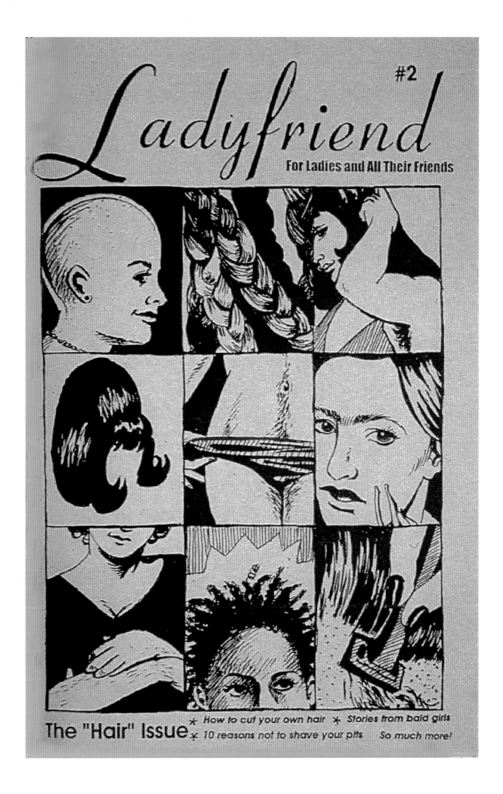

**CHRISTA DONNER** *Ladyfriend #2* (cover), 2001
Xeroxed & stapled paper
8 x 5 inches
Courtesy of the Artist

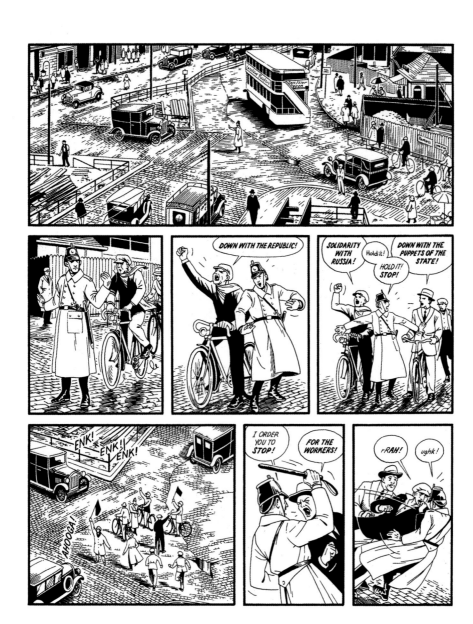

**JASON LUTES** *Berlin City of Stone* (page 172), 2000
Pen and ink on Bristol board
15 x 11 inches
Courtesy of the Artist

**ENRIQUE CHAGOYA**  *Cartography*, 2002
Acrylic on amate paper, mounted on linen
48 x 48 inches
Collection of Moises and Diana Berezdivin
Courtesy George Adams Gallery, New York

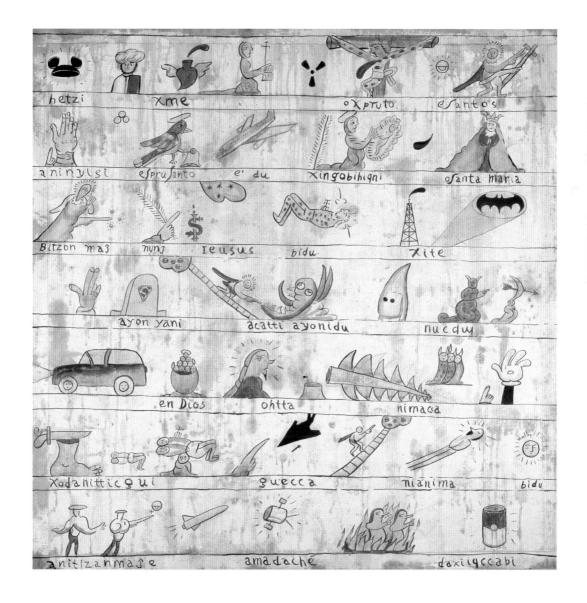

Can comics be ART?
It is — I'm sorry — a really  STUPID
question! But if we must answer it,
the answer is YES.

**Scott McCloud**

*Understanding Comics* (New York: Kitchen Sink
Press for Harper Perennial, 1993), p. 163.

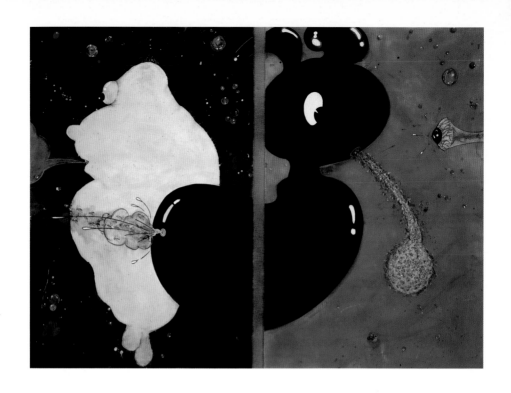

**SALLY FRENCH**  *In Which Ballzo Talks Bubblespeak & Olive Farts Bees*
and *In Which Olive Sucks Bees on Candyass Pinks*
From *Bee Bop*, 2002
Alkyd, oil pastel, Prismacolor, paper, toner, gnats on wood panel
66 x 91 inches
Courtesy of the Artist
Photo: Robert Herold

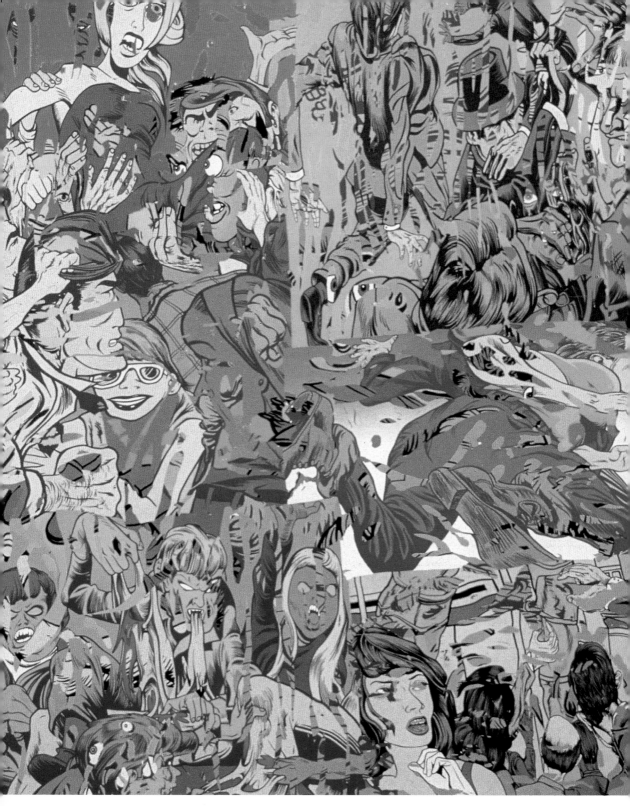

**CHRISTIAN SCHUMANN**  *Wanted*, 1999
Acrylic and mixed media on canvas
72 x 60 inches
Collection of Hubert Newmann
Courtesy of the Artist

**JULIETTE BORDA**  *Three Men*, 1996
Gouache on paper
4¹/₄ x 7³/₄ inches
Courtesy of the Artist

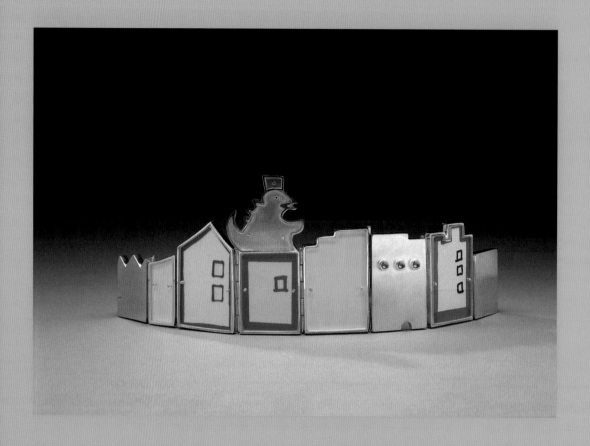

**ROY** *Godzilla with Fez Bracelet*, 2002
Fabricated and hinged silver, rag paper, non-reflective plexi-glass, nickel, brass clasp
8 x 2 x ³/₈ inches (open)
Courtesy of the Artist
Photo: Dean Powell

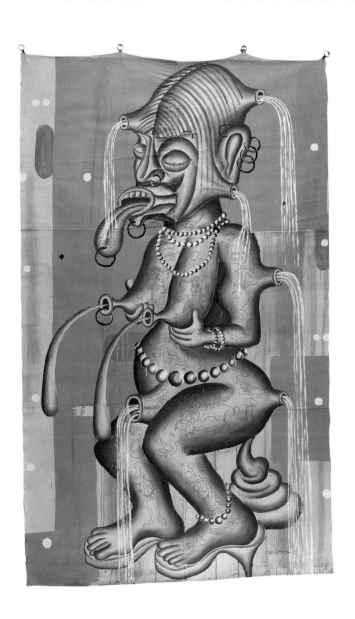

**CISCO JIMÉNEZ**  *Diosa de La Fertilidad Ovulando*, 2000
Acrylic on canvas
102 x 63 inches
Courtesy Galeria Ramis Barquet, New York
Photo: Adam Reich

# Dykes To Watch Out For  by Alison Bechdel

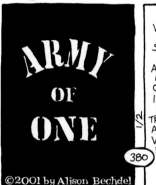

ARMY
OF
ONE

©2001 by Alison Bechdel

380

ON VACATION WITH SYDNEY'S FATHER AND STEP-MOTHER. OUR HERO-INE FINDS HERSELF TRAPPED IN A HELLISH VORTEX OF FRIVOLITY AND EXCESS.

HERE'S THE PAPER. SURE YOU DON'T WANT TO COME TO THE SPA, MO?

NO, I'M ALL SET. I JUST HAD MY NOSTRILS WAXED LAST WEEK.

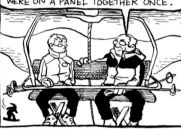

MEANWHILE, ON THE SLOPES...

WHY DON'T YOU SEND SOME OF YOUR ARTICLES TO STANLEY STURGEON, SYD? A LETTER FROM HIM WOULD **CINCH** YOUR TENURE. MENTION MY NAME. WE WERE ON A PANEL TOGETHER ONCE.

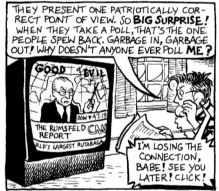

THEY PRESENT ONE PATRIOTICALLY COR-RECT POINT OF VIEW. SO **BIG SURPRISE!** WHEN THEY TAKE A POLL, THAT'S THE ONE PEOPLE SPEW BACK. GARBAGE IN, GARBAGE OUT! WHY DOESN'T ANYONE EVER POLL **ME?**

GOOD EVIL

THE RUMSFELD REPORT

RLD'S LARGEST RUTABAGA

I'M LOSING THE CONNECTION, BABE! SEE YOU LATER! CLICK!

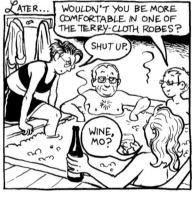

LATER...

WOULDN'T YOU BE MORE COMFORTABLE IN ONE OF THE TERRY-CLOTH ROBES?

SHUT UP.

WINE, MO?

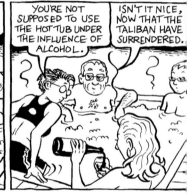

YOU'RE NOT SUPPOSED TO USE THE HOT TUB UNDER THE INFLUENCE OF ALCOHOL.

ISN'T IT NICE, NOW THAT THE TALIBAN HAVE SURRENDERED.

www.dykestowatchoutfor.net

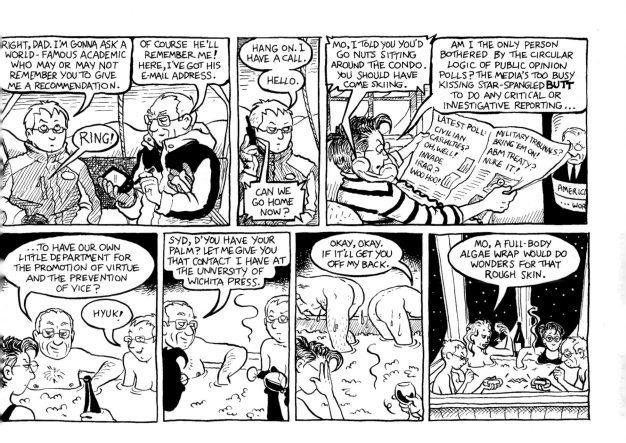

ALISON BECHDEL  *Army of One*
From *Dykes To Watch Out For* (episode 380), 2001
India ink on Bristol board
11 x 14 inches
Courtesy of the Artist

**BRAD KAHLHAMER**
*Funny US Smoke Signals*, 2000
Oil on canvas
64 x 84 inches
Collection of the Artist
Courtesy Deitch Projects, New York

CHRIS FINLEY   *Sweat Daddy Double Stretched Remix*, 1999
Acrylic sign enamel on canvas over wood
72 x 72 inches
Courtesy ACME, Los Angeles

**MATT MADDEN**  *Odds Off* (part 4, page 12), 2001
India ink on paper
14 ¹/₂ x 11 inches
Courtesy of the Artist

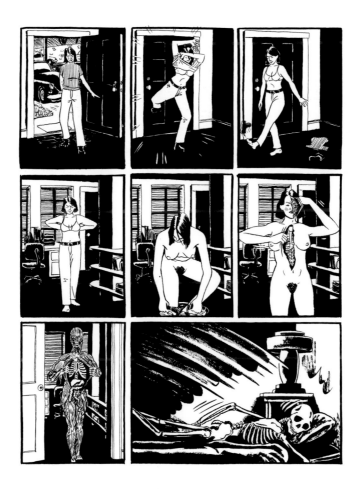

**DANIEL HEIMBINDER**  *An Impossibly Inhospitable World*, 2001
Watercolor and ink on paper
22³/₄ x 30¹/₂ inches
Courtesy Clementine Gallery, New York

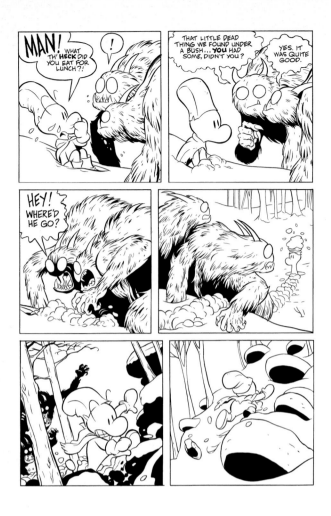

**JEFF SMITH** *BONE* #2 (page 8), 1991
15 x 10 inches
Blue pencil and ink on 2-ply Bristol plate
Collection of the Artist

**LESLIE LEW**  *Wonder Woman-Again-Saves the Day*, 2001
Sculpted oil on board
38 x 28 inches
Courtesy of the Artist

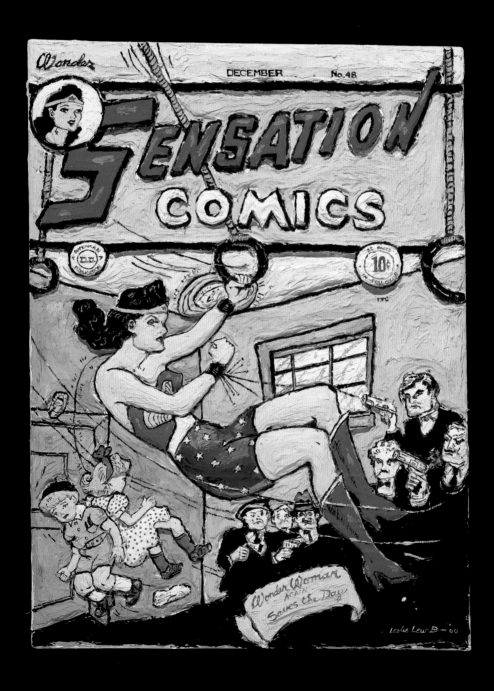

62

**LAYLAH ALI** *Untitled*, 2002
Gouache, watercolor pencil & ink on paper
12 x 11¹/₂ inches
Courtesy 303 Gallery, New York

# The Creative Multiplicity of Comics

ANA MERINO

The comic is a narrative and visual art form capable not only of showing the expressive voice of its creator but of constructing elaborate visual connections that can represent or challenge, among other things, the reality of the present, memory, myths, the subconscious, identity, and culture. Arising at the end of the nineteenth century, the comic has been able to adapt its expressive possibilities to the different times and places where it has developed. It has found accommodation in the ephemeral space of the newspaper, through strips and political cartoons, and it has attained permanence as an object in the form of comic books and graphic novels.

How should we understand comics in the postmodern world? In the United States, there is a tendency to associate comics with superheroes (Marvel or DC). Themes in these traditional comics rely on the dynamic between good and evil and focus primarily on the entertainment of children and teenagers. But comics also belong to a much larger creative and cultural dimension. They are engaged in deep and intense explorations, at times more so than any other visual art form because they use language, with all its oral intensity, in the visual art space. Since the 1960s, creators of comics have sought to insert new and multiple spaces into the comic landscape, departing radically from the superhero formula and constructing adult narrative voices. They brought an underground perspective to elaborate questions confronting social reality. Authors such as Robert Crumb, Justin

Green, Frank Stack, and Gilbert Shelton offered satirical voices that poked fun at religion and the conservative American values of their times. They developed counterculture comics whose narrations went against the establishment, whose perspectives fought the unfair system and made readers look with critical eyes. Sex also became an avenue for the artist to represent his hidden desires, especially in Crumb's construction of women. And women, in turn, as creators as well as newly empowered characters, defined the future of comics in the 1980s and 1990s by throwing off their role as objects of sexual desire and expanding the themes of representation.

### WHEN MEN LEARN TO BE WOMEN BY MAKING COMICS

Gary Groth, the editor and publisher of the *The Comics Journal* as well as publisher and owner with Kim Thompson of Fantagraphics Books,[1] remembers clearly when he saw the work of the Hernández Brothers for the first time: "I received a copy of *Love & Rockets* #1 in the mail straight from the publishers in (I think) late 1981. I was so taken by it that I wrote a rave review of it for *The Comics Journal*, and must've sent them back a note of thanks. In short order, I offered to publish it for them, they readily agreed, and we've been doing it for twenty years now."[2] This decision to publish the work of these two brothers marks the beginning of the alternative comics movement in the United States.

*Love and Rockets* #1 was a comic created and self-published by Jaime and Gilbert Hernández, with input from an older brother, Mario, and financial support from their younger brother Ismael. They offered stories about people, mostly women, confronting a "transculturate"[3] reality and searching for themselves within it—an approach whose potential Groth recognized when he took over the publishing and editing duties:

> Their work was, above everything else, liberating. Although you could detect influences here and there, their work was *sui generis*. Both Gilbert and Jaime had what I considered an unselfconscious and, uncharacteristically for the world of comics, healthy attitude about sex. It was the first comic that I remember seeing that didn't view sex as a taboo to be smashed, but as a natural part of life.

1    *The Comics Journal* was founded by Gary Groth in 1976 and is considered to be one of the most important critical and theoretical references about comics and the comic industry. Fantagraphics is the main publisher of alternative comics and of key importance in the history of comics over the last twenty-five years. Among the artists represented are the Hernández Brothers, Daniel Clowes, Joe Sacco, Chris Ware, Peter Bagge, and Dave Cooper. Fantagraphics also keeps the memory of classic comics alive by reprintings in the form of books and albums the works of Hal Foster (*Prince Valiant*), Winsor McCay (*Little Nemo*), Harold Gray (*Little Orphan Annie*), Walt Kelly (*Pogo*), E. C. Segar (*Popeye*), and Jules Feiffer (*Tantrum*). They also reprint the works of key authors in the underground movement such as Robert Crumb and Kim Deitch.

2    All quotes by Gary Groth are from a conversation with the author, San Diego, 2002.

3    I understand "transculturation" to mean the way in which two different cultures interact and become integrated into the lives of the people who confront them as part of their everyday reality. Jaime's characters confront their Chicano and Latino origins within the American cultural landscape, whereas Gilbert's characters waiver between their small Latin American village called Palomar and the United States.

That representation of sex in a natural manner, through the eyes and the voices of female characters, is what made these stories revolutionary in both narrative and visual ways. Their work allowed a new mode for understanding femininity and opened a field in comics where the gender of the author became irrelevant to articulating the narration with expressive intensity. Gilbert and Jaime's stories reflect, on a deep level, their own mixed heritage as children born and raised in America whose parents emigrated from Mexico. Their works incorporate the oral storytelling tradition of Latin American culture and mix it with their own love of comics and punk rock.

The two brothers, though sharing similar passions, developed two completely different story lines and styles. The main universe, created by Gilbert, involves an imaginary location called Palomar, which is a quiet village in a mythical "South" that is perhaps somewhere in Central America or maybe even closer to the U.S. border. It is a mysterious geography that Gilbert draws, and he explains: "Palomar's quite isolated, even for a small town. The closest train station is in Felix. There's a public bus that comes up from Felix but that's only if the driver isn't too lazy and pretends to stop here."[4] There is one panel where a map is drawn to set the scene. On the coast is the village of Palomar, which looks out on the Islands of the Pioio Indians. To the east are the Mountains of the Ciencia Indians, and between the mountains and Palomar lies La Balala Desert. One of the main characters is Luba (called la India), an intelligent and intense woman with a very voluptuous body, especially her breasts. She has an extensive family and a very complicated love life. Gilbert portrays her life and the lives of her children and her sisters with amazing literary intensity, including the temporal reality whereby the characters grow up as time passes and as they confront their own existence.

Another very special character is Fritz, one of Luba's half-sisters. Since her teenage punk years, Fritz has had a very promiscuous sexual life, though she manages to keep her ability to love intact. As a young punk rocker she makes the following powerful and beautiful statement: "The first punker was Lilith, who was born before Eve and banished from Eden because she was too hard for Adam to handle."[5] Through Fritz, Gilbert gives form to the true soul of his female characters, all descendants of Lilith.[6] But Lilith is not presented here as a negative woman who joined the forces of evil. Rather, Gilbert breaks the mythical misogynist assumption that women cannot be equal and in his art gives women the space they deserve.

Jaime also created a group of women characters that belong to the new Lilith mythology, in which women can be free and independent thinkers. The main characters are three girls: Maggie, Hopey, and Penny, all of whom we watch grow up over the years. All three inhabit the punk landscape during their teenage years, but follow different paths in trying to understand reality and passion. Jaime's stories utilize a more theatrical representation: his characters are on stage, living their lives in intense and crazy ways. Friendship is understood as a form of love where sex is, again, something quite natural. Jaime pays homage to music throughout the frames, which sets a very graphic and strong rhythm to the stories.

Groth notes another important aspect of the Hernández Brothers' work, namely, their ability to reflect on the position of the comic artist vis-à-vis his or her own art. Gilbert and Jaime, believing in the expressive power of this medium, forged an independent path, caring first and foremost about the telling of their stories:

> They didn't take their cue from other work being published. They had an I-don't-give-a-shit attitude, as in, they didn't give a shit what any other artists were doing at the time, they were going to do their work their way and if it was uncommercial, so be it, and to hell with anyone who didn't like it. They still have this attitude and I still like it.

The Hernández Brothers opened the door to many other artists who use alternative comics' storytelling tradition. But they also opened another door—one that liberated women from being secondary characters and enabled them to speak with passion in voices of their own, in all the possible and multiple ways that graphic creation allows.

> **The creative multiplicity of comics allows women to find their way into graphic expression, not only as fictitious characters but as artists themselves.**

Peter Bagge and Daniel Clowes, among others, would follow the road of creating stories about individuals and their ways of dealing with life and reality. These two artists have built their narratives around the difficult transition from adolescence to young adulthood, and their stories represent a type of contemporary *Bildungsroman*. Their protagonists are directionless youths in an America that has lost its ability to dream. Alongside this fictional narrative approach is another that reclaims the presence of the graphics creator as an active being. James Kochalka, a prolific artist who deals with autobiography through personal diaries, fictive narratives, and meditations on what it means to produce a comic, has cultivated such a space of self-reflection in his work.

---

4   Gilbert Hernández, "For the Love of Carmen," in *1980–1990: The Best Comics of the Decade* (Seattle: Fantagraphics Books, 1990), p. 3.

5   Gilbert Hernández, *Luba in America* (Seattle: Fantagraphics Books, 2000), p. 141.

6   Tradition considers Lilith to be the Queen of the Night: "Jehovah created her out of mud to be Adam's first wife.... Eventually she deserted Adam to join Satan's henchmen, and Jehovah created her replacement by fashioning Eve out of one of Adam's ribs." [Michael Page and Robert Ingpen, *Encyclopedia of Things That Never Were* (Harmondsworth, England: Penguin Books, 1985), p. 225.]

## WHEN WOMEN USE COMICS TO BE THEMSELVES

The creative multiplicity of comics allows women to find their way into graphic expression, not only as fictitious characters but as artists themselves.[7] This shift can be traced back to the underground efforts of artists such as Mary Fleener, Roberta Gregory, and Donna Barr, who demonstrated the possibilities of inserting ideological feminism into the countercultural space of the comics. In the late 1980s Fleener developed a neo-cubist cartooning style in her autobiographical collection *Life of the Party*, in which she describes her experiences as an art student and a musician in California, and the way she and her pals enjoy their sexuality. Artist and writer Ray Zone has remarked on Fleener's description of her work as "autobiographix" and explains that this subgenre "evolved out of the underground comix of the 1960s" and that "this form of confessional comic story, highly candid and shockingly truthful, was a necessary byroad for graphic narrative to explore in order for it to 'mature' into a legitimate means of artistic expression."[8] For her part, Roberta Gregory created two important female characters. The first, Bitchy Bitch, becomes a parody of the concept of female hysteria as she goes through the different stages of her life. The second, Bitchy Butch, is defined by Gregory as the world's angriest dyke. Using a cartoon style and with strong humor, Gregory introduces complex themes such as pornography, self-abuse, and the perpetual unhappiness of a sick consumer society.

The autobiographical feminine space reaches its most bitter and poetical levels in the works of Julie Doucet, Debbie Drechsler, and Phoebe Gloeckner. Their voices do not stop at a simple description of life experience but reconstruct fears and anxieties, weaving a confusing path between the real and the imaginary. Doucet tells the story, among others, of a woman filled with anxiety about her own body who tries to imagine what it would be like if she were a man. In another story the woman becomes an aggressive giant monster roaming the streets of the city in the middle of the night in search of tampons. Doucet also narrates, in a very personal style, her passion for nightlife, dreams, and drinking as well as her enjoyment of sex and her inability to maintain a relationship. Gloeckner's stories, like those of Drechsler, recount in a realistic way the painful loss of innocence. In her work, girls are never safe from the abusive masculine society that uses them.

Feminine voices acquire enormous force in a space dominated by men. Carol Lay, in her *Story Minutes*, builds short graphic stories of great complexity that reflect upon existence, memory, and the fantastic. Her vast array of female main characters includes an old lady who wins an award that allows her to be God for a day, and a woman with a couple dozen personalities. Many of her stories have social content and criticize, for example, economic inequalities and the ecological destruction of the planet.

Other feminine voices in this panorama meditate on the present moment and its social and ideological conflictedness. Lynda Barry, with her pliable narrative, cultivates various spaces, emphasizing that of childhood but also concerning herself with portraying the scenographies of

those most marginalized by economic disparity, as in her trailer park stories. In a dynamic of great expressive intensity is the sordid realist work of Renée French. Her imaginary, unlike that of Lay or Barry, does not attempt to decipher anxieties or existential doubts but rather creates incredibly pessimistic tales that reflect a sick and abandoned society. Her black-and-white pages depict kids who are cruel to animals and adults who just don't care about anything but their own pleasure. Alison Bechdel also uses a critical perspective to deal with contemporary society in her strip *Dykes to Watch Out For*. Bechdel is a humorist who tries with sarcasm to empower various communities that challenge the repressive American way of life. Most of her main characters belong to the lesbian community, but there is also diverse racial representation in her work and an acute political awareness of the present. Her strips play with reality, with current news events, to get across her leftist ideological points. In this sense she has much in common with Peter Kuper, whose universe questions the very foundation of the political process in the United States, as he hopes for the best for democracy. Both Bechdel and Kuper reveal the fragility and the conflicts of the present moment.

The voices of younger generations fluctuate between graphic narrations as a literary space, most notably in Jessica Abel's work, and as legendary mythic space, as in the works of Megan Kelso and Linda Medley. Abel follows the alternative comics' literary style inaugurated by the Hernández Brothers. She combines beautiful, realistic drawings with very solid narrations, as in her ongoing story *La Perdida*, which recounts the adventures of a young American woman of Mexican heritage who tries to find her identity in Mexico City. Abel utilizes two narrative levels—one that deals with the everyday life of an insecure young woman and another that plays with the Mexican historical, cultural, and political context in symbolic terms. The use of the socio-cultural symbolic gives an asexual dimension to her comics and makes her a gender-free comic artist. She doesn't need to tell stories about herself to find her creative voice or to build strong female characters. Her protagonist is interesting because of her human weaknesses, and the story is strong because Abel is not looking for some sort of salvation or redemption.

The legendary mythic space of Megan Kelso is apparent in her *Artichoke Tales*, a group of stories in which the main characters live in a land comprising a traditional peasant world. Linda Medley's series *Castle Waiting* is a delicate, crafty work that uses medieval scenography to recover the art of children's storytelling with a multidimensional eye able to incorporate adults as part of the readership. Her work, and that of others, represents a postmodern recuperation of legendary tales of fairies, witches, and princesses.

---

7   For an interesting chronology of the history of woman in comics and of female characters, see Trina Robbins, *From Girls to Grrrlz* (San Francisco: Chronicle Books, 1999).

8   Ray Zone, introduction to Mary Fleener, *Life of the Party* (Seattle: Fantagraphics Books, 1996), p. 10.

### WHEN THE SUBALTERN SPEAKS THROUGH COMICS

The founding statement of the Latin American Subaltern Studies group declares "in cultural production, the emergence of testimonial and documentary form shifts dramatically the parameters of representation away from the writer and the avant-gardes."[9] The state of urgency so inherent in the testimonial form developed not only in the context of Latin America but across the globe. Comics, as a cultural space, incorporate both testimonial and documentary forms, offering the possibility of representing subaltern subjects who in and of themselves form a part of the construction of the text. This kind of comic, epitomized in the work of Art Spiegelman or Joe Sacco, evolved in part in response to the male-centered meta-narratives of mainstream comics' superheroes. They provide an alternative which I would define as one of the strongest vanguards of the underground comic scene. Testimonial gives emphasis to the concrete, to the personal, focusing on the minuscule details of the lives of women, political prisoners, and the marginalized.

Spiegelman's *Maus*, for example, is a comic in which the direct recuperation of the past forms the basis of its theme. The past, and the search for truth through memory, are the cornerstones of the narration. Written and drawn by Spiegelman over the course of thirteen years, *Maus* represents an effort to recuperate the author's family roots from a variety of perspectives. It is easy to describe this work as simply an autobiographical commentary about the author's father, Vladek, in which Vladek describes his hardships in Auschwitz. But in *Maus* various chronological moments and diverse parallel stories are developed in which the testimony of the father forms the central axis but depends upon the others for its context.

For critic John Beverley, testimony is a narrative told in the first person by the protagonist or by a witness to the events that he or she is relating. In many cases, this narrator is someone who is illiterate, or simply someone literate who is not a writer. The production of testimony, according to Beverley, "often involves the tape recording and then the transcription and editing of an oral account by an interlocutor who is an intellectual, journalist, or writer." Further, Beverley points to the importance of remembering that testimony is a narrative of urgency: "a story that needs to be told—involving a problem of repression, poverty, subalternity, exploitation, or simply survival."[10] In its subtitle, *Maus* indicates that it is a "survivor's tale," and the book possesses all of the elements that make up a testimonial. For Spiegelman, his work "was intentionally made for readers," although "the engine in *Maus* is [his] father's narrative, a verbal construct."[11] This "verbal construct" permits the truth to be analyzed from another perspective, using testimonial as a literary instrument for representing memory.

Comics have succeeded in creating a dialogue with history and providing their perspectives on and interpretations of epochs and events. Joe Sacco, a war comics-journalist, collects the memories of those who have suffered in the Palestinian conflict or during the war in Bosnia. Continuing his involvement with issues of war, Sacco created *War Junkie*, a very critical and satirical comic about

the uses and abuses of the media in portraying the Gulf War events. In a somewhat different vein is Sacco's *Take It Off*, which recounts the story of Susan Catherine, a stripper.

## WHEN COMICS VISIT THE MUSEUM SPACE

The final format of the comic, as it normally appears on the pages of a newspaper, magazine, or book, is quite simple. However, underlying it is a very complex process of creative elaboration that is divided into numerous steps. First, the creator (when talking about a comic not done as a group effort) has to ideate a story, a plot, and a basis upon which graphic imagination can develop. He or she must be capable of integrating with perfect harmony a double language, that of words and that of images, in a sequential space fragmented into frames. This intellectual process takes shape on the drawing board, as the creator will pencil-draw on paper or cardstock a first version of the graphic narration later to be inked. The artist can choose to insert color in the original (or not), depending on the developing style or taste. Some artists color using traditional methods; some use the computer to insert color during the editing process.

On the original page one can perceive not only the creative labor but also the artisan refinement that the process entails. The creator of comics is an artist in many ways, adapting different expressive traditions to an art form contained in a book. It is certain that using the computer as a space of narrative contention offers various limitations and problems that depend on the qualities and the processor speed of the computer, whereas a book constitutes a much more manageable and autonomous finished piece. But both books and computers are spaces of expressive contention and artistic dissemination. Whereas most works of art (paintings, sculpture, and installation works, for example) normally depend on the museum space to reach a large audience, in the case of comics, the actual finished work is distributed in multiple copies via the relevant channels—comic book shops and bookstores. Although comics develop by creative processes similar to those in painting and literature, the final stage of production—namely, reproduction—is the ultimate medium for comic books. As such, why is it necessary to display the original pages of a comic in a gallery or museum if the finished work is the printed object that contains all the sequential graphic narration?

The comic as a final printed object creates a dialogue with the reader and with other books. The original page shown in an exhibition represents the creator within the context of the museum. It opens the work to another public and establishes a dialogue with other artistic expressions. Perhaps this museum exhibitionism is a form of fetishization; nevertheless it also shows the flexibility of comics and the artistic dimensions of their creators. In each panel there lies a singular creative

9    John Beverley, *Subalternity and Representation: Arguments in Cultural Theory* (Durham, N.C., and London: Duke University Press, 1999), p. 140.

10   John Beverley, *Against Literature* (Minneapolis and London: University of Minnesota Press, 1993), pp. 70–73.

11   Quoted in *The Comics Journal*, 180 (September 1995), p. 65.

force that connects sequentially with the other panels. The art lover has a right to know the multiplicity of the comic and to recognize within its elaborative process that individual creative step where the hands are the instruments that project and sketch out the comic artist's imaginary.

A show that displays comic art on museum or gallery walls brings to the canonical artistic space of the museum a new type of artist who struggles through a career that does not always garner the same recognition accorded to other artists. Why is an installation more appealing to a curator than an original page from a comic book? What is the public looking for when they enter a museum? One might say that placing comics in the museum environment is a way of trivializing art. However, comics are perhaps the least trivial of works in that they are subject to a continual narrative that can be conceived and appreciated either fragmentarily or as part of a whole. Whether or not a work in book form enjoys market popularity should not have any bearing on the aesthetic and expressive value and importance of a work. All of the tendencies shown here—from the most realistic aesthetic to the most cartoonish approach—construct narratives that consolidate a multiplicity of media.

> **The comic artist is not looking to curators, collectors, or institutions for validation; the audience is his or her primary concern, the audience of regular people as an open space.**

We can see a new landscape of artists, including Chris Ware and Charles Burns, who try to strengthen their spaces on both narrative and graphic levels. Comic artists today affirm that their dialogue with low culture now needs to extend to high culture. They also show how boundaries are continually broken in new ways in order to represent culture. This is a culture in which the creator draws the limitations of reality in panel format, showing that the simplicity of combining words and drawings in a narrative fashion can be the most direct and effective interpellation. The art from these comic creators looks for a new public able to follow and to share their aesthetic visions. These are perspectives that have a strong narrative component and yet independent interpretations can be seen in every single panel.

The expressive and artistic diversity that comics offer, within a framework of formal simplicity, is solidified as a far-ranging ideological object. Every frame speaks to the reader, creating a narration that will always be articulated around a system of ideas. The imagination in comics has many possibilities, but will always be attached to the creator who tries to insert the reader into his or her frames. The new generation of alternative comic artists are free to represent their own notion of the real and to believe in the force of their work as an aesthetic and narrative weapon that establishes dialogue with readers and forces them to think. Artists such as Daniel Clowes, the Hernández

Brothers, and Joe Matt even include a section with readers' letters in their serial publications. The comic artist makes the reader participate in the process of the work because the audience is, in fact, what gives the work its meaning—an audience that doesn't need any formation other than the ability to read and to enjoy graphic expression. The comic artist is not looking to curators, collectors, or institutions for validation; the audience is his or her primary concern, an audience of regular people as an open space—a space that can be filled with imagination, a sense of hope, and critical compromises from every perspective.

The comic must reclaim its space in canonical cultural representation. Its marginalized aesthetic and expressive capacities ought to be recovered and re-examined in spaces of cultural recognition such as museums, libraries, and universities. New readings and discourse of comics must be articulated, ones that reflect on the creative dimensions of comics and their contemporary testimonial capacity, not only as consumer products able to persist in collective memory but as individual forms of creative multiplicity that seek out an engaged reader, a reader capable of making sense of the comic's graphic voice and therein recognizing an existential depth that connects rational, or irrational, margins of creation to reality.

**ANA MERINO**, is Assistant Professor of Spanish at Appalachian State University in Boone, North Carolina, where she teaches Hispanic Cultural Studies and Literature. Dr. Merino's doctoral dissertation about comics, *Del Cómic Hispánico*, will be published in 2003 by Catedra edit. She has previously published three books of poems and won the 1994 Adonais poetry award. A member of the ICAF (International Comic Arts Festival) Executive Committee, her articles on comics—more than 40—have appeared in *Leer*, *DDLV*, *The Comics Journal*, *AGAQUE*, *Revista Latinoamericana de estudios sobre la Historieta*, *International Journal of Comics Art* and *Hispanic Issues*.

Ana Merino would like to thank Peter Birkemoe, Gary Groth, Natalia Indrimi, Steven Andrew Knauss, Eric Reynolds, and Eric Kim Thompson, who helped to secure loans, and Derec Petrey, who worked on the translation of her essay.

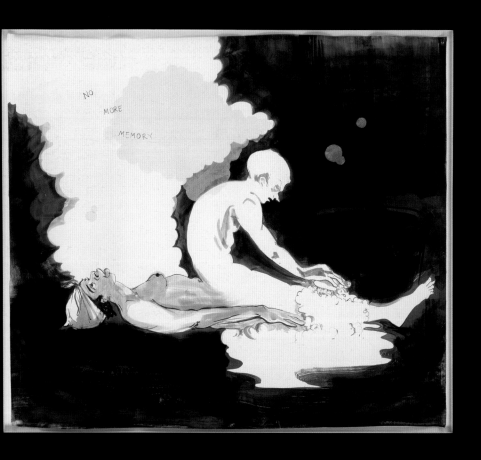

CAROL LAY *Sign Language*, 2002
Ink on paper
15 7/8 x 11 1/2 inches
Courtesy of the Artist

**But almost everyone understands a commonplace comic strip without any need for explanation.**
**You don't need to know anything, apart from the shared knowledge we all posess about contemporary everyday life, to interpret comics.**

**David Carrier**

*The Aesthetics of Comics* (University Park: The Pennsylvania State University Press, 2002), p. 163.

**DAVE MULLER**  *He Could Sell Snowballs To.....*, 2002
Acrylic and aluminum paint on paper
80 x 64 inches
Courtesy of the Artist and Blum & Poe, Santa Monica, CA
Photo: Joshua White

**JULIE DOUCET** *Monkey and the Living Dead,*
*Part Two: Search of the Mysterious Faucet* (page 5), 1990
India ink on paper
Courtesy Peter Birkemoe and The Beguiling, Toronto

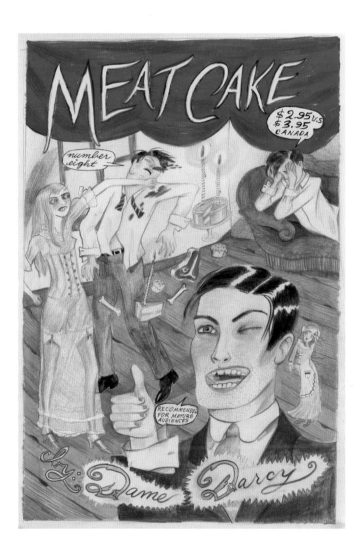

**DAME DARCY** *Meatcake* #8 (cover), 2002
Watercolor, ink, and pencil on paper
14 x 11 inches
Courtesy Richard Heller Gallery, Santa Monica, CA

# EIGHTBALL

## MAINTAINING AN ICY DISTANCE BETWEEN ARTIST AND READER SINCE 1989

### I'M SURE I WOULDN'T KNOW!

SO DANIEL,
CAN I WRITE A LOVE LETTER TO ENID? GOD, SHE IS THE TOTAL SHIT. IF YOU WRITE HER NAME BACKWARDS IT SPELLS DINE, BUT I GUESS YOU ALREADY KNOW THAT... IF I'VE GOT A HUGE CRUSH ON HER DOES THAT MEAN IT'S YOU THAT I TRULY HAVE FEELINGS FOR?

DELIA GONZALEZ
NEW YORK, NY

DEAR MR. CLOWES,
I'M AN ART SCHOOL STUDENT INTERESTED IN COMICS WHOSE ALL-MALE COMIC BOOK CLASS PRODUCED THAT I POSE AS THE 'DIZZIER' IN A SPANDEX JUMPSUIT FOR THEM.

CHRISTY MCCAFFREY
PROVIDENCE, RI

DANNY,
COME ON, FOUR BUCKS? I CAN STILL GET A FULL MEAL IN THIS TOWN FOR THAT KIND OF DOUGH. (MAY I RECOMMEND MAN-JO-VIN'S ON DAMEN — ED.) I CAN STILL CATCH A MATINEE FOR THAT, DANNY.

EDDIE CONNOLLY
CHICAGO, IL.

DEAR EIGHTBALL STAFF,
IT SEEMS CLEAR THAT THE READERS AND CREATORS OF YOUR MAGAZINE CONSIST LARGELY OF SOCIETY'S PSEUDO-VICTIMS. PEOPLE WHO THINK THE WORLD HAS GIVEN THEM A SHIT LIFE PURELY BECAUSE THEY HAVE BEEN UNABLE TO DEVELOP THE SOCIAL SKILLS TO INTERACT WITH THOSE AROUND THEM. WELL READERS, TRUE SUCCESS IS MEASURED IN TERMS OF INTER-ACTIVE RELATIONSHIPS, NOT PERSONAL ACHIEVEMENTS. I HOPE THAT YOUR READERS CAN BE HONEST ENOUGH TO REALIZE THAT THEIR 'PEOPLE HATING' ATTITUDE IS UNWORTHY OF CREATIVE MINDS. I WISH YOU PROGRESSION.

ALEX WALLIS
ENGLAND

DEAR MR. CLOWES,
THANK YOU SO MUCH! I FEEL LIKE A CELEBRITY! UNFORTUNATELY, I DON'T KNOW ANYONE ELSE WHO READS EIGHTBALL... I HATE MELORRA BUT I LOVE JOSH, ESPECIALLY WHEN HE WAS LOOKING AT THOSE BUTT-PLUGGERS IN NUMBER FOURTEEN.

NATALIE LARIOS
HIGHLAND MILLS, NY

2.

### OPPOSITES ATTRACT

"Not quite, Mr. Pessimist. I'm saying that Hitler's nut-sack was half-full."

### INSECT

**EIGHTBALL # 17** EIGHTBALL IS PUBLISHED SEMI-ANNUALLY AND IS ©1996 FANTAGRAPHICS BOOKS, INC. ALL CHARACTERS, ART AND STORIES © DANIEL G. CLOWES. NO PART OF THIS COMIC MAY BE REPRODUCED WITHOUT WRITTEN PERMISSION FROM FANTAGRAPHICS OR MR. CLOWES. NO SIMILARITY BETWEEN ANY OF THE NAMES, CHARACTERS, PERSONS OR INSTITUTIONS IN EIGHTBALL AND THOSE OF ANY PERSONS LIVING OR DEAD IS INTENDED OTHER THAN FOR SATIRICAL PURPOSES. ANY SUCH SIMILARITY THAT MAY EXIST IS PURELY CO-INCIDENTAL. LETTERS TO EIGHTBALL BECOME THE PROPERTY OF MR. CLOWES AND ARE ASSUMED INTENDED FOR PUBLICATION. FIRST PRINTING : AUGUST 1996. **PRINTED IN CANADA.**

WRITE TO
EIGHTBALL
2140 SHATTUCK
SUITE 2107
BERKELEY
CALIFORNIA
94704

### ORIGINAL ART?

YOU WANT? WE GOT! EIGHT-BALL, LLOYD LLEWELLYN, ETC. SEND $5 (CASH ONLY) FOR OUR CURRENT PRICE LIST!

SEND TO: EIGHTBALL 2140 SHATTUCK #2107 BERKELEY CA. 94704

### POWERMASTER

"You'll get no help from me — you caused your own problems, young man."

### THE LEPIDOPTERIST

"Excuse me. Someone is using a bad pun in the next panel."

**DANIEL CLOWES** *Eightball #8* (title page), 1992
India ink on illustration board
19 x 12¼ inches
Collection of Eric Reynolds, Seattle, WA

80

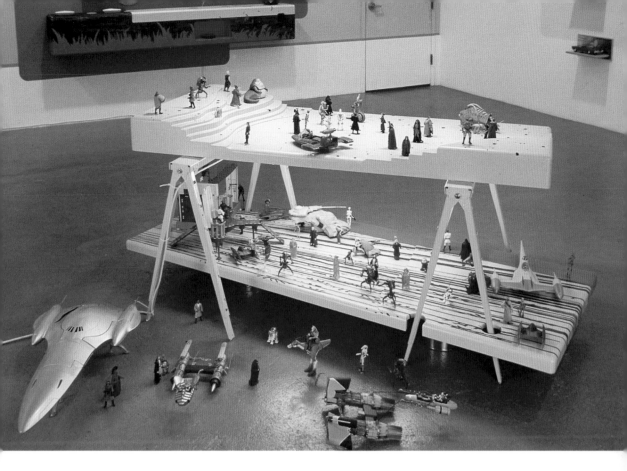

**RYAN HUMPHREY** *Ultra Geek* (Episode 1), 2001
Plywood, enamel paint, Star wars figures, metal saw horses, fluorescent and incandescent lights
74 x 82 x 92¼ inches
Courtesy Caren Golden Fine Arts, New York
Photo: Oren Slor

**GRENNAN & SPERANDIO**  *The Invisible City* (cover), 1999
10 ³/₈ x 7 inches
Courtesy of the Artists

**AL SOUZA**  *Sparklers*, 2000
Puzzle parts and glue on wood
41 x 48 inches
Collection of Ken Tyburski, New York
Courtesy Charles Cowles Gallery, New York

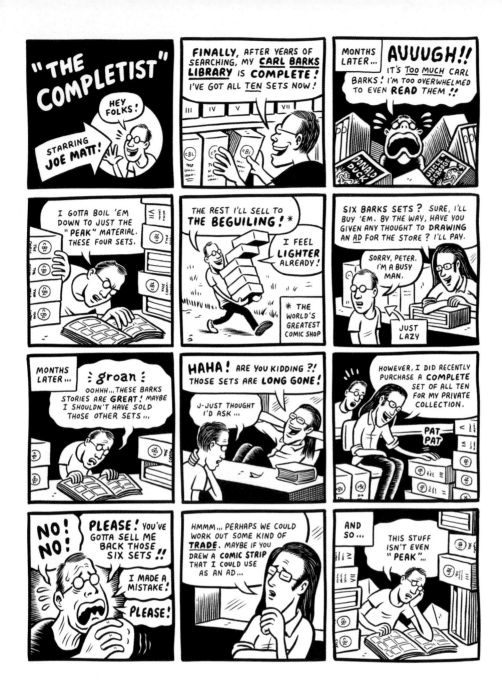

**JOE MATT** *The Completist*, 2002
9 x 12 inches
India ink and Liquid Paper on illustration board
Courtesy of Peter Birkemoe and The Beguiling, Toronto

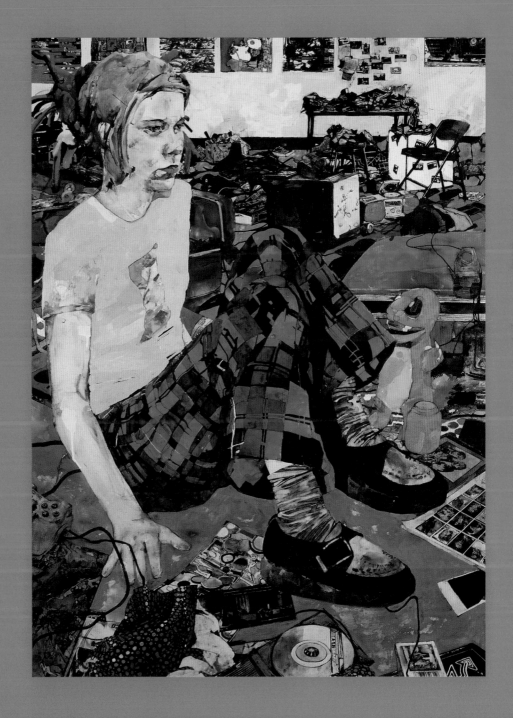

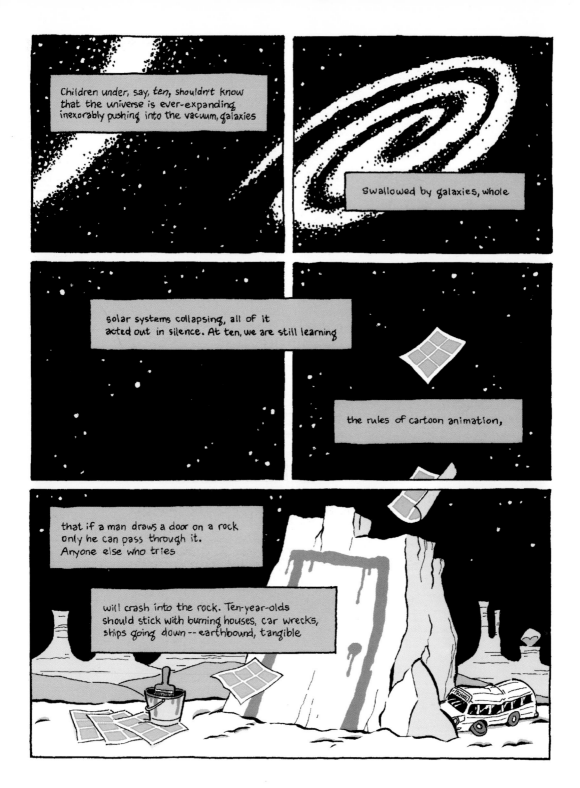

Children under, say, ten, shouldn't know that the universe is ever-expanding inexorably pushing into the vacuum, galaxies

swallowed by galaxies, whole

solar systems collapsing, all of it acted out in silence. At ten, we are still learning

the rules of cartoon animation,

that if a man draws a door on a rock only he can pass through it. Anyone else who tries

will crash into the rock. Ten-year-olds should stick with burning houses, car wrecks, ships going down -- earthbound, tangible

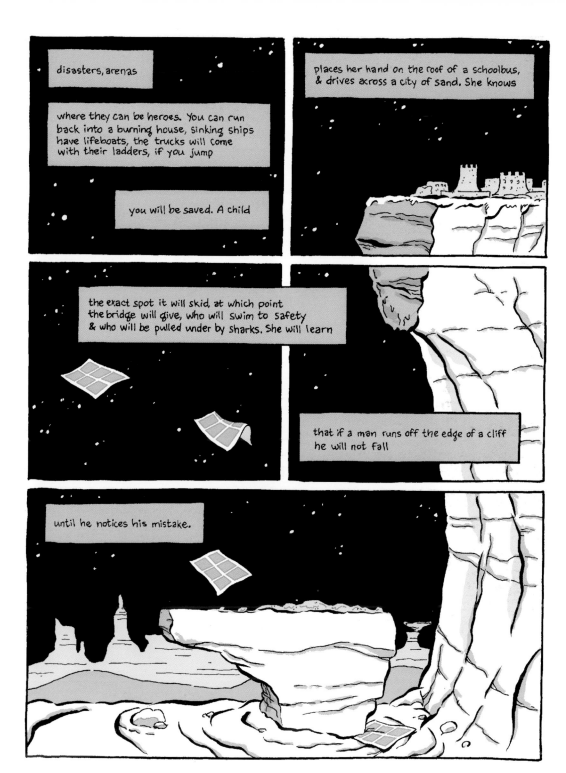

**JOSH NEUFELD** *Cartoon Physics Part II*, 2001
Brush pen, marker on Bristol board
17 x 11 inches each
Courtesy of the Artist

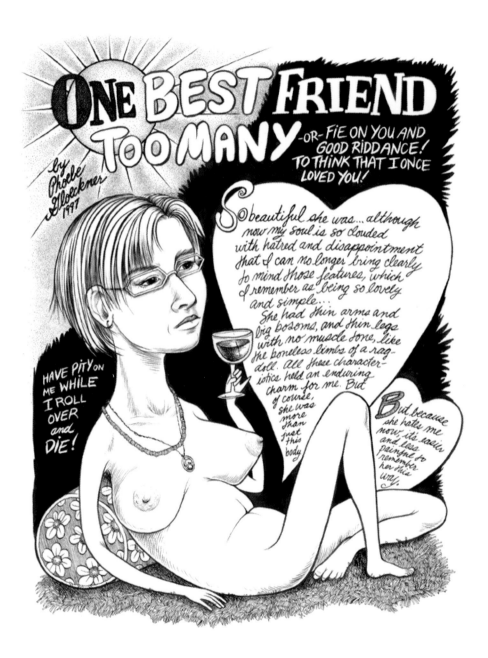

**MYFANWY MACLEOD**  Study for '*Thought*', 1999
Vacuum-formed plexiglass
23 x 45 x 13 inches
Collection of Laing and Kathleen Brown
Courtesy Catriona Jeffries Gallery, Vancouver

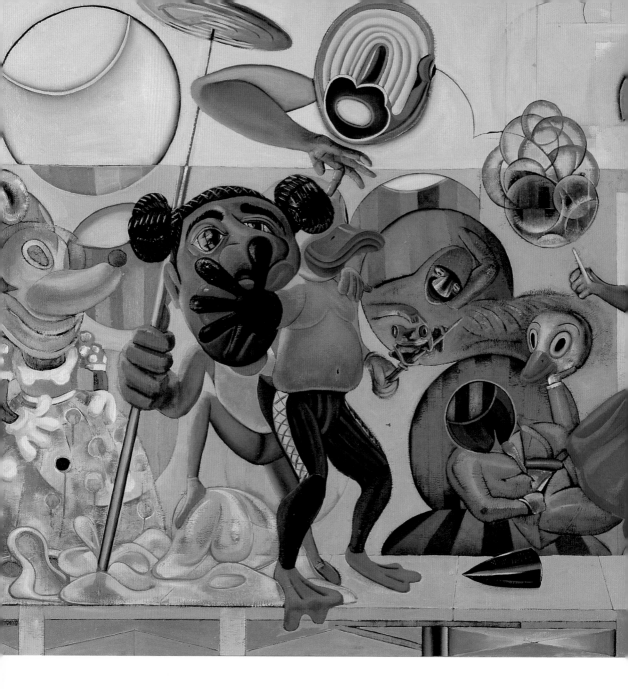

**PETER WILLIAMS**  *Opera Bouffe*, 2000
Oil on canvas
52 x 106 inches
Courtesy Revolution Gallery, Detroit
Photo: Tim Thayer

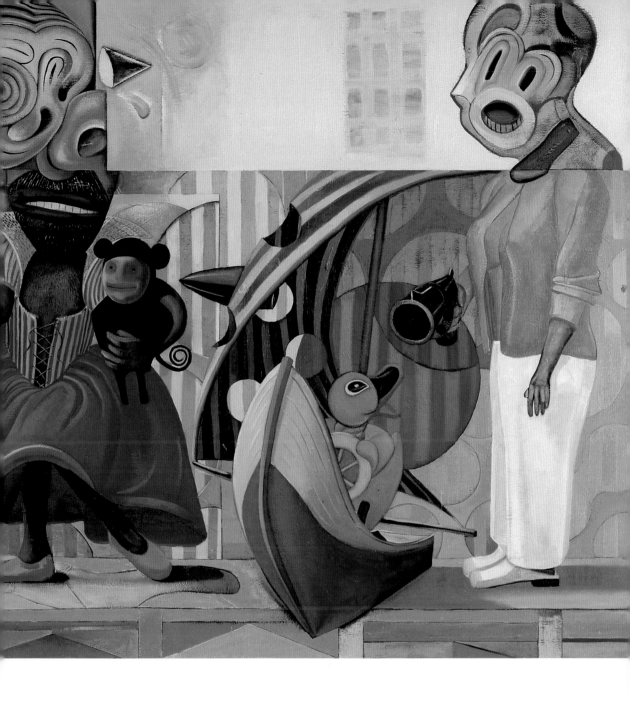

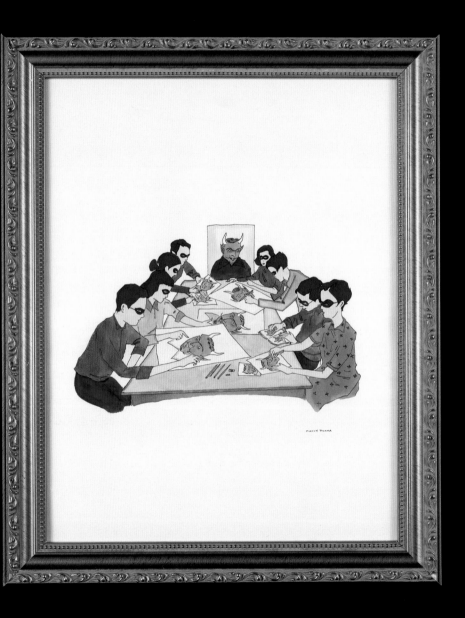

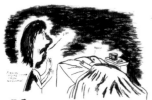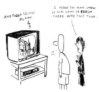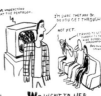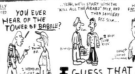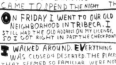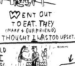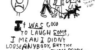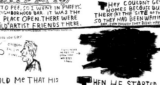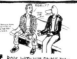

**JIM TOROK**  *One Week*, 2001
Ink on paper
37 1/2 x 49 3/4 inches
Courtesy Bill Maynes Gallery, New York

**Is it ok to laugh yet?**

BARBARA BLOEMINK

Today, cartoon-based imagery shows up everywhere, including, increasingly, in contemporary art galleries and museums across the globe. As immediately recognizable cultural icons, cartoon styles and imagery have become a universal language that enables the transmission and hybridization of often difficult, provocative ideas in a progressively homogenized and sanitized world.

Comic imagery and stylization are often the means of seducing audiences into the work, a strategy similar to what Dave Hickey described in the 1990s regarding the role of beauty as a subtle invitation drawing viewers in to close consideration of often controversial subject matter.[1] In Japan, for example, cartoon figures are used on subway billboards as part of a campaign to end sexual harassment and to warn molesters that they will be punished; likewise, New York City subway cars are the site of a popular long-running comic strip dealing with AIDS and drug use.

The definition of what is considered "art" has ultimately blurred to include functional objects, advertising, postcards, comics, signs, computer games, movies, billboards—that is, almost anything that gives primacy to visual consideration. In this context, notions of high versus low art are meaningless.[2] As cartoon artist Dave Cooper notes, graphic novels (the form in which many cartoons currently appear) are "susceptible to the same pathetic good/shit ratio (about 5% to 95%) as every other medium or artform."[3]

Even traditional distinctions between art and comics have become moot, including the idea that works of art are unique whereas comics are characterized by almost unlimited reproduction. Many artists of graphic novels, such as Daniel Clowes and Ben Katchor, specifically limit the published editions of their works, following the model of limited-edition artist's books. Concurrently, mountains of glossy periodicals and Internet JPEGs duplicate images of contemporary art for millions of readers/users, making the works globally accessible almost as soon as they are created. Comic books have become the "art periodicals" and the visual textbooks for the young and disenfranchised. Cartoonist Eric Powell recently avowed, "I cater not to the intellectual elite, but to the little fat kids dressed like Klingons everywhere who have no chance of getting a girlfriend. I fill the voids in their lives and that's more important than selling a fish head hot glued to a stick for sixty thousand dollars."[4]

Part of the appeal of cartoons is their perceived ability to provide the instant gratification that lies at the center of twenty-first century consumer culture. As a result, cartoon-based imagery and programs are regular fare today on television and in movies from Hollywood to Japan. But few of the contemporary works that reference comics have humor as their underlying motivation. In fact, many forms of cartoon humor are not overtly funny; instead they are characterized by an underlying nastiness that confirms a condition we know to be true, despite outward appearances. As the inventor of *MAD* magazine observed, "Satire and parody work only when you reveal a fundamental flow of truth in your subject."[5] It is the nature of comedy to draw the viewer in one direction, then hit them from another (the old twisteroo), which is often more disconcerting than funny. As noted art historian Ernst Gombrich remarked, the essence of wit is the "telescoping of a whole chain of ideas into one pregnant image."[6] The works in *Comic Release* cause less of a guffaw in viewers than a grim smile and a nodding acknowledgment of the truths conveyed in the imagery and (when applicable) the accompanying narrative.

1    See Dave Hickey, *The Invisible Dragon: Four Essays on Beauty* (Los Angeles: Art Issues Press, 1993).

2    Recently, graphic novels and comic strip artists have been the recipients of honors formerly reserved for so-called fine art: Ben Katchor won the prestigious MacArthur award; Joe Sacco was awarded a Guggenheim Foundation Fellowship for his series on Bosnia; Chris Ware has been nominated for numerous literary awards for his graphic novel *Jimmy Corrigan: The Smartest Kid on Earth*; Daniel Clowes' graphic novel *Ghost World* was made into a Hollywood movie; and Max Alan Collins/Richard Piers Raynor's graphic novel *Road to Perdition* was adapted into a film starring Paul Newman and Tom Hanks. The original novel was itself based on a Japanese graphic novel, *Kozure Okami*, by Kazuo Loike and Goseki Kojima with a similar violence-laden story exploring the psychology of the father/son bond.

3    Dave Cooper, "Why Comic Books?," *New Observations* 125 (spring 2000), p. 32.

4    Eric Powell, "Them Funny Books Is High Art," *New Observations* 125 (spring 2000), pp. 22–23.

5    Harvey Kurtzman and Michael Barrier, *From AARGH! To ZAP!—Harvey Kurtzman's Visual History of the Comics* (New York: Prentice Hall, 1991), p. 41.

6    Ernst Gombrich, "The Cartoonist's Armory," in *Meditations on a Hobby Horse, and Other Essays on the History of Art* (New York: Phaidon Press, 1963), p. 130.

Like contemporary art, today's graphic novels display elasticity capable of dealing with any sub-ject, including the Holocausts of WWII and Bosnia, pornography, religion, cancer, violence and war, urban alienation, sexual and drug abuse, racial bigotry, and even the very real terrors of childhood. Both art forms are characterized by their egalitarian, postmodern appropriation and cannibalization of styles and subjects from the past and the present. To the dismay of many French critics, Stéphane Heuret recently converted Marcel Proust's sixteen-volume novel *Remembrance of Things Past* into a graphic novel. As of this writing, the first volume already has sold 50,000 copies and is being translated into English. Meanwhile, an animated cable television program, *Harvey Birdman: Attorney at Law*, follows the professional efforts of its title character, a prestigious law firm's token "superhero." Birdman is responsible for defending all of the firm's cartoon clients, many of whom now find themselves in circumstances quite different from those in which they usually appear. In one episode, for example, Birdman defends Scooby Doo and Shaggy against drug possession charges.

The graphic style of cartoons and comic imagery are comforting, initially seducing us with memories of a simpler past. Made up of the bright, primary colors of finger paints applied as thickly as cake frosting, Leslie Lew's works are visual nostalgia, throwing us back to an imagined gentler time with icons of our childhood. Lew's painted bas-reliefs trace the golden age of comics, with images from Dick Tracy to Flash Gordon standing as icons of American culture. The paintings cre-ate immediate associations as we identify different classic cartoon characters, and remember when we first encountered Little Lulu or were drawn into the dramas of Brenda Starr and Terry and the Pirates.

For many of us, reading cartoons as children and teenagers was not just a means of escaping the confusion of daily life but a method of structuring and dealing with the world's complexity. Comics and cartoons also provided a cathartic outlet for releasing some of the anxieties and tensions of child-hood. As Bradford W. Wright, the author of *Comic Book Nation*, recalls, comics provided:

> ...a fantasy world that made more sense than the real one. When I grew old enough to contemplate
> such things, I learned that those comic books had not only afforded me an escape from a confusing
> reality, they had helped me to perceive reality in terms that I could understand and accept. Comic
> books helped me to define myself and my world in a way that made both far less frightening. I honestly
> cannot imagine how I would have navigated my way through childhood without them.[7]

In his 1904 novel *Peter Pan*, J. M. Barrie reinforced every parent's fantasy, commenting that, "It is the nightly custom of every good mother after her children are asleep to rummage in their minds and put things straight for the next morning, repacking into their proper places the many articles that have wandered during the day....When you wake in the morning, the naughtiness and evil passions with which you went to bed have been folded up small and placed at the bottom of your mind; and on the top, beautifully aired, are spread out your prettier thoughts, ready for you to put on."[8]

Despite parents' best intentions, however, "childhood innocence" is increasingly a misnomer in contemporary life. Adults, needing to maintain this illusion, often forget what a cruel and terrifying experience childhood can be. As many of the artists in this exhibition demonstrate, the varied uses of imagery of fantastic creatures and fabricated situations often are layered with the complexities that characterize aspects of real life.

Kojo Griffin paints psychologically charged, open-ended fairy tales. Over shallow backgrounds painted with scientific notations, Chinese characters, Hebraic symbols, and twisted strands of DNA, Griffin collages interactions between strange figures resembling children's stuffed toys: elephants, bears, and round-headed dolls with visible seams bisecting their heads. Animated by their postures and gestures, Griffin's figures are expressionless. Each enigmatic tableau depicts the cartoonish characters within emotionally disturbing circumstances such as child molestation, physical abuse, and even murder. Whether depicting a figure in isolation so lonely that he considers suicide, or a stranger enticing children with the offer of candy, Griffin's themes are universal and, too often, accurately represent the fears and terrors of contemporary existence.

Although parents may fervently wish for their children's daydreams to be filled with kindly cartoon characters, the imaginative musings of children are often closer to the sharply ironic imagery of Gottfried Helnwein's painting *American Prayer*. Painted in blue grisaille tones offsetting the superficial innocence of its subject, the German artist's work ostensibly conveys the private longings of a small boy kneeling to say his evening prayers. Surprisingly, the boy's thoughts are not turned toward a deity but to a smirking, slightly malicious Donald Duck. In fact, close viewing of the painting reveals that the child is not human, but has hinged screws at his wrists and awkwardly flat, wooden hands. In Helnwein's world, Pinocchio dreams not of being a boy, but of becoming a cartoon character.

During their formative years, children mine information from their surroundings in an inherently messy, often fragmented manner as they "bring together, in the artifacts produced in play, materials of widely differing kinds in a new intuitive relationship."[9] Contemporary artists such as Steven Weissman, Debbie Drechsler, Peregrine Honig, and Yoshitomo Nara stylistically and emotionally capture the reality of children brought up in a world where terrorism, divorced parents, and computerized isolation have become the norm.

Weissman's graphic novels return viewers to the often nasty pecking order imposed by children when they detect a weakness in one of the group. Debbie Drechsler's *Daddy's Girl*, which has been translated into several languages, deals with themes of parental incest and sibling rivalry. Despite

7   Bradford W. Wright, *Comic Book Nation* (Baltimore: The Johns Hopkins University Press, 2001), pp. ix–x.

8   J. M. Barrie, *Peter Pan* (New York: Signet, 1987), pp. 5–6.

9   Walter Benjamin, "One Way Street," in *One Way Street and Other Writings*, ed. Susan Sontag (London: NLB, 1979), p. 74.

the sweetness implied by its lacy paper-doily design, Peregrine Honig's *Ovulet* is actually a visual coding of various traumas experienced by prepubescent girls. Each letter of the alphabet illustrates, via corresponding graceful drawings, vicious acts ranging from sexual abuse and eating disorders to self-mutilation. With tiny touches of color emphasizing certain focal areas, Honig's work is cool and detached, as if all emotion has been drained from the work as well as from the prematurely jaded young girls.

By contrast, Japanese artist Nara's paintings are populated by sly, cynical, menacing children, with bared teeth and hostile expressions, some brandishing knives. These children, with their huge, disproportionate heads resembling cartoon characters, all display feelings of alienation, anxiety, anger, and above all, powerlessness. According to Nara, in these works he is articulating the scream of a generation that has no power and shares a commonality of hopelessness.

Children are more prone to improvisation than adults and they are not predictable, two qualities that might define significant artworks as well as the best graphic novels. Their refusal to "stay within the lines" often defines a recognition of the unique nature of children's creative powers, which usually disappear with the self-censorship of maturity. As Picasso once observed, "What might be taken for a precocious genius is the genius of childhood. When the child grows up, it disappears without a trace."[10]

> **As immediately recognizable cultural icons, cartoon styles and imagery have become a universal language that enables the transmission and hybridization of often difficult, provocative ideas in a progressively homogenized and sanitized world.**

In Arturo Herrera's recent drawing *Night Before Last*, the lines have unraveled. Only gradually is Snow White's goofy companion, Dopey, vaguely visible at the right. In the fantasyland of his work, Herrera explores the boundary between childhood and maturity, between the visible and the hidden. Rather than containing colors within them, the lines now explode and drip off the page with the destructive energy of a child. Herrera's act of creative improvisation symbolizes the unraveling of memories, the instability of the facade of innocence where exact meaning constantly mutates.

Teenage years are also common fodder for many contemporary artists. The gang from Archie comics is the focal point for a number of recent works by Peter Mitchell-Dayton. The redheaded character, whose romantic aspirations (perky Betty or glamorous Veronica?) filled the minds of scores of viewers, is revealed to have a rich fantasy life. Archie's bubble daydreams, like those of

many an adolescent, revolve around sex and erotic fantasies of his female comic counterparts as well as of alluring, older women posturing like porn stars. The contrast of innocence and sexual desire is rendered stylistically through the use of comic and realistic draughtsmanship within the same work.

In many cities worldwide, graffiti appears on every visible surface as evidence of the boredom and the futility felt by generations of adolescents with few cathartic outlets and a lot of time to spare. To differing degrees, the sense of alienation and isolation manifest in this form of expression is identifiable in the works of a number of artists, including Christian Schumann, Barry McGee, and Chris Johanson. These artists freely borrow from characteristically urban visual media to address themes such as drug abuse, deceit, monotony, internal conflict, and fear or inability to engage in an adult world of compromise, accepted hypocrisy, and seemingly corrupt institutions.

Barry McGee uses his barrel-headed, racially ambiguous, "sad sack" figures to "capture both the melancholia and the sensory overload we experience while walking down the street of any contemporary American city."[11] McGee's clusters of small paintings and glass bottles convey the urban debris of the overlooked, the marginalized, and the transients who are ever-present in our urban dystopias. The raw, poignant, and nonlinear narratives of Chris Johanson's installations serve as metaphors for the random encounters and eccentricities of urban life. Like the characters in Ben Katchor's graphic novels, many of Johanson's figures are shown marginalized and discarded, disillusioned with life. Some are portrayed bent over, "charred" as the artist describes it, by the weight of life—from bills to office politics. "I try to show people—happy people, sad people, angry people, people who drink and do drugs too much, business people who work too much. I try to show society as a whole." Johanson often paints directly on raw and found materials, including wood boards, as a metaphor for his subject: "It's really important to me that it's raw and weathered just like the people that I draw."[12]

Alienation is not unique to cities. The melancholic isolation of adolescence in suburbia is captured equally in Daniel Clowes' graphic novel *Ghost World* and in Zak Smith's painting *Jill, Tasty, on the Floor*. Jill is portrayed seated on the floor of her room, surrounded by the debris of contemporary teenage life. Clothes lie in piles adjacent to CDs, food, paints, and stuffed animals abandoned and left over from childhood. Everything in the room has been consumed and abandoned. The young men in Michael Bevilacqua's painting *Disposable Teens* stand aimlessly against a psychedelic background. They are stereotypical of their age and generation, and strangely lack any affect, despite being covered entirely with brand name labels intended to highlight their individuality. The blue-haired teen wearing eye makeup, the pig-snouted redhead, the boy with an

10    Quoted in Gyula Brassaï, *Picasso and Company*, trans. Francis Price (Garden City, N.Y.: Doubleday, 1966), p. 86.

11    Exhibition statement for *Barry McGee*, UCLA Hammer Museum, Los Angeles, February 6–June 4, 2000, <http://www. hammer.ucla.edu/exhibits/barrymcgee>.

12    Chris Johanson, interviewed by Clare Guerrero, KRON-TV, San Francisco, 1997.

imprint of a wooden panel in place of his face, and the strange, looming fright-masked young man in the lower left corner lack any animation. Despite the accumulation of imagery, from red-cross signs to the graffitied names of contemporary rock bands, each of the teens is isolated, even from those standing at his side.

In the early 1960s artists Roy Lichtenstein and Andy Warhol appropriated existing imagery of Mickey Mouse and Popeye in their paintings. Ever since, many artists have used existing, recognizable cartoon characters in their work. The context in which these characters are portrayed today, however, is a far cry from the Pop sensibility. These universally recognized characters are used to express all the mishaps, foibles, and vulnerabilities of human existence. Today, in paintings and sculpture as well as in many graphic novels, the cartoon protagonists find themselves in often disturbing circumstances that are quite different from those their original creators intended.

Many artists use cartoon animals as doppelgängers, or doubles, for humans, displaying all of their vulnerabilities and character flaws more effectively than would be possible through more realistic depictions. Mickey Mouse is the ultimate human alter ego. As George Dardess notes, "Mickey Mouse is amusing, not because he is a mouse, but because he is a mouse behaving in some of the silly ways in which we behave. But silliness doesn't tell the whole story of our behavior. Mickey's least human-like trait isn't his big ears or his long tail. It's his lack of a tragic dimension."[13]

Mickey is instantly and globally recognizable and represents, for better or worse, the hegemony of Caucasian American pop culture. Many foreign critics today complain that globalization of trade and social mores is turning the world into an American-dominated, bland, boring, homogeneous society. Mexican-born artist Enrique Chagoya uncovers in his work evidence of cultural cannibalism's legacy. In his horizontally expansive *Cartography* and paintings such as *An American Primitive in Paris*, Chagoya plays on the cumulative effect of colonial expansion on formerly indigenous civilizations. Referring to his work as "reverse anthropology," Chagoya uses Disney characters "as contrast for the drama of life."[14] He combines historical stereotypes from Aztec and Spanish Colonial art with cultural symbols and icons (from Mickey Mouse and Batman to Warhol's soup cans and Ku Klux Klan figures) to create multilayered manuscripts of cultural chaos.

Currently many international artists—from countries including Colombia, Mexico, France, Israel, Germany and Japan—appropriate Mickey Mouse in a manner quite foreign to Disney's original concept. Though rarely portrayed as tragic, Disney's mouse in many of these works is a sinister character, reflecting widespread nationalistic fear of the exploitation of the imagination of their young and impressionable viewers by the Hollywood dream machine. Bogotá's Nadín Ospina molds "pre-Columbian" Mickeys in both two- and three-dimensional form. Shaped like terra-cotta Peruvian ceramics, Ospina's Mickey Mouse noticeably displays his sexual attributes. Although a common motif in pre-Columbian pottery, this overt sexuality is disturbing in Ospina's work given its contemporary focus. Meanwhile, Israel's Eliezer Sonnenschein constructs a three-dimensional

Mickey holding an Uzi painted with red, white, and blue stars and stripes. His body is "branded" with American products, including Levis, Adidas, and *TV Guide*; the side of the gun is inscribed with the words "Live or Die," and the expletive "Motherfucker" continues down his arm. Teeth bared and grinning, Sonnenschein's Mickey, like many of Israel's populace, waits at the ready to defend himself.

In French-Canadian artist Michel Boulanger's *Nature anxieuse*, Mickey Mouse (read Disney World) rampages carelessly through an eighteenth-century countryside, stomping everything in sight. The landscape is painted in muted brown tones (*en grisaille*) while freshly cut pieces of realistically rendered horse meat in the foreground ironically refer to the French-Canadian "consumption" of American culture. Throughout Boulanger's composition, various Disney characters morph out of floating plinths or three-dimensional puzzle pieces. They fill the sky like descending aliens, reinforcing the callousness of contemporary American culture as experienced by many other western cultures.

> **Like contemporary art, today's graphic novels display elasticity capable of dealing with any subject, including the Holocausts of WWII and Bosnia, pornography, religion, cancer, violence and war, urban alienation, sexual and drug abuse, racial bigotry, and even the very real terrors of childhood.**

A three-dimensional sculpture by Vancouver artist Myfanwy MacLeod consists of two large oval eyes, hung on an empty wall. They are immediately recognizable as belonging to Mickey Mouse, even without the context of a body. As in the best eighteenth-century portraits, the lidless eyes have an eerie ability to seemingly follow each viewer's movements across a room. These huge eyes evoke notions of Big Brother or F. Scott Fitzgerald's T. J. Eckleburg, whose eyes noticed everything from the billboard over Wilson's garage. In MacLeod's sculpture, Mickey's huge eyes pass judgment on everyone in the vicinity, conveying that everything is ultimately viewed through the lens of American popular culture.

In their bold lines and simplified compositions, eighteenth- and nineteenth-century Japanese Ukiyo-e prints were the comic books/graphic novels of their time. Despite a long tradition of beautifully rendered graphic novels, Japanese artists in the twentieth century initially experienced an inferiority complex toward Disney and the dominance of American society. As a result, during

---

**13**　George Dardess, "Instructor's Guide," in *Foreign Exchange: A Novel* (Rochester, N.Y.: Austen Press, 1994), p. iv.

**14**　Quoted in Elisabeth Sherwin, "Strong Influence on Chagoya? Mickey Mouse!," *Davis Enterprise/Winters Express*, January 14, 1999, p. 12.

recent decades an enormous number of Japanese artists and illustrators have begun using American cartoon imagery to simultaneously allure and alienate audiences. The resulting works are often cruel and disturbing. Leading the charge is Takashi Murakami, whose Hippon factory, an homage to Warhol, churns out cartoonlike representations for films, commercial use, and consumption as "fine" art. Using *kawaii* or "cute" imagery, Murakami has created a main protagonist named DOB, Mickey Mouse's evil twin. On any given week, DOB can be found hovering ominously in pneumatic balloons and oversized paintings in museums and art galleries across the world, his sarcastic expression a leer rather than a grin. Claiming that "Art is not universal, but more like fashion with a longer life span,"[15] Murakami reproduces DOB in various commercial guises, including on T-shirts, mouse pads, toys, and watches.

Mickey Mouse is also a popular icon used by many African-American artists in their work. Peter Williams uses Disney's mouse and Mouseketeer hats to confront issues of identity, bigotry, and stereotyped depictions of blacks in art. In his recent paintings, artist John Bankston similarly combines imagery and methods of working from coloring books, African-American slave narratives, Disney films, and fairy tales to address "issues of self definition, power, dominance and redemption."[16]

In *Brooms*, Bankston revisits a pivotal scene from Walt Disney's film *Fantasia* using graphic lines of animation and swirls of abstract color. In the segment known as the "Sorcerer's Apprentice," the film follows the antics of Mickey Mouse as the title character, who in his master's absence transforms the studio into chaos. Eventually, as water engulfs the chamber, disembodied brooms dance across the screen, sweeping out everything in sight. In the painting, the brooms similarly cavort through an ambiguous space, with Mickey's disembodied eyes and mouth looking on, horrified. Since so many of Bankston's paintings deal with issues of race, *Brooms* suggests a second reading with its implication of identity being swept "under the rug," with the floating pop-eyes recalling racist, nineteenth-century stereotypes of African-Americans.

In addition to using cartoon imagery and stylization (Glenn Ligon's coloring books, Kara Walker's silhouettes and sepia drawings, etc.), a number of contemporary African-American artists "load" their compositions with images from vintage posters, ephemera, and leaflets playing on the overt racism of America's past. The shocking nature of these paintings recalls one of Picasso's definitions of art: "Art is never chaste. It ought to be forbidden to ignorant innocents, never allowed into contact with those not sufficiently prepared. Yes, art is dangerous. Where it is chaste, it is not art."[17]

In Michael Ray Charles' *Beware*, a grinning young "pickaninny," with nappy pigtailed hair and Mickey Mouse hands, whistles as he lopes across an otherwise empty scene. Rendered in flat, opaque paint on a roughly treated board, the painting resembles a vintage poster. The provocative imagery angers many viewers who feel that audiences might not always understand the ironic nature of these works and will use them instead to confirm their own racist tendencies. In most of Charles' work, the mood and meaning is left highly ambiguous. In *Beware*, for example, Mickey's

characteristically white-gloved hands are held in tight fists, reminding viewers that Mickey is a *black* mouse, constantly pursued by white adversaries. The white gloves are also a trademark of Michael Jackson, an African-American whose increasingly whitened skin and morphing physiognomy have turned him into a caricature of himself. In *Beware*, the prancing, whistling boy is dressed in the gold-buttoned shorts of a cartoon character and appears to be the picture of innocence. As a result, the word "Beware," written in large letters below him, is disconcerting. Are we to "beware" the whistling boy and what he may become, or the degrading message of the portrayal?

Today, our perception of violence takes many forms. From domestic and racial violence to terrorism and war, it is increasingly difficult to distance ourselves from its presence in our daily lives. Violent subject matter has a long history in art and in the progenitors of modern graphic novels. Early medieval imagery often depicted scenes of religious wars, torture, and persecution, as did German woodcuts that graphically explored subjects of morality, crime, and political intrigue. During the eighteenth and nineteenth centuries, caricatures by Hogarth, Callot, and Goya often portrayed major themes with undertones of war, anarchy, and violence—topics that served for centuries as subject matter for countless paintings, prints, photographs, and sculptures.

Early animated cartoons, especially those made by artists from Warner Brothers Studios, traded heavily on the cathartic release of seeing bumbling cartoon characters squashed, pummeled, shot, and falling off huge cliffs, only to rise and resume their antics. As Gottfried Helnwein recalls of his childhood:

> When I opened the first comic, I felt like someone who has been buried in a mining accident and emerges into the daylight again…I was back home in a reasonable world where one could be flattened by roadrollers or riddled with a hundred bullets without being harmed; I was in a world in which people looked decent once more, with yellow bills and a black knob for a nose.[18]

Many classic cartoons from the early twentieth century, particularly those geared toward children, were based on violent circumstances that normally would be fatal. In such cartoons the absurdity of the situations often makes violence the focal point of the narrative's humor. The catastrophic calamities experienced by the characters are usually the result of either malicious pranks or their own stupidity. Sylvester, the sputtering tuxedoed cat, spends a good portion of his film time peeling his body up after being flattened by the weight of falling objects. In Fabian Ugalde's painting

15   Murakami, quoted in Kay Itoi, "The Wizard of DOB," *Art News* 100, no. 3 (March 2001), pp. 134–7.

16   Undated artist's statement issued by the Studio Museum of Harlem, New York, on the occasion of the *Freestyle* exhibition, May 2001.

17   Quoted in Antonina Vallentin, *Pablo Picasso*, chapter 11 (Paris: A. Michel, 1957).

18   Quoted in Alexander Borovsky, ed., *Gottfried Helnwein* (St. Petersburg: The State Russian Museum, Palace Edition, 1997), p. 177.

*Fallen Landscape*, Sylvester's body is similarly squashed around a projecting form resembling a bomb that is being fed through a series of metal cylinders. In the background, a floating, verdant landscape disintegrates against a cloudy blue sky. A projectile below reads: "Anyone is a good substitute."

A far cry from Leon Golub's vivid paintings of Vietnam War veterans of the 1970s and terrorism and torture of the 1980s, contemporary artist Laylah Ali's treatment of war and violence is as distanced and remote as a comic. Ali's Greenheads and Blueheads are androgynous, hybrid, generic figures with no distinctions in terms of race. All of the figures are the same height and most wear uniforms, creating the impression of homogeneity and conformity. As a result, it is difficult to determine which group is the aggressor and which the victimized, who wields the greater power and to what end. Once seduced into close viewing of Ali's enigmatic mini-dramas, tiny details reveal the atrocities of war: hangings, executions, amputated limbs, and severed, disembodied heads pass between figures like bowling balls. We are drawn to the artist's use of bright flat colors and delicately rendered figures that are arranged in chains running horizontally across the page. However, once we understand their true nature, our initial delight in the drawings makes us complicit in the indifference and distance with which the painful subject matter is treated.

As Disney realized in such films as *Bambi*, anthropomorphizing animals allows artists to draw attention to events and issues that viewers would otherwise prefer to avoid. Many psychologists have cited the death of the fawn's mother early in the film as a means of helping children experience the losses that are part of everyone's life. Art Spiegelman's Pulitzer Prize–winning 1972 graphic novel *Maus* explored the lack of humanity in Nazi concentration camps. Commenting on his use of cats and mice as metaphoric stand-ins for Nazis and Jews, Spiegelman observed: "If one draws this kind of stuff with people, it comes out wrong…. I'm afraid that if I did it with people it would be very corny. It would come out as some kind of odd plea for sympathy…. To use these ciphers, the cats and mice, is actually a way to allow you past the cipher [to] the people who were experiencing it. So it's really a much more direct way of dealing with the material."[19]

Spiegelman recently wrote a *New Yorker* article praising Bernard Krigstein as one of the artists who most influenced his work.[20] In 1955, Entertainment Comics published a limited run of Krigstein's graphic novel *Master Race*. At the time, there was little in the mass media that accurately described either the Nazi's genocide or the conditions in the death camps. The information was only beginning to circulate, and many found the events too atrocious to be believed. In his work, Krigstein did not spare the sensibility of the reader. On page four, panel seven, for example, ordinary citizens from the town adjacent to a death camp cover their mouths with handkerchiefs against "the stinking odor of human flesh burning in the ovens… men's… women's… children's." Unfortunately, at the time of *Master Race*'s publication, the public was unwilling to deal with the subject matter, and it received very little attention.

Indicating the difference in the reception of graphic novels today, many see "comic strip journalist" Joe Sacco as Spiegelman's contemporary successor in using the graphic style and the immediacy of comics to deal with issues of violence and war. In the mid-1990s, Sacco spent four months living in the Muslim enclave of Gorazde, while the area was being bombed by Bosnian Serbs. The experience resulted in a 240-page graphic novel, *Safe Area Gorazde: The War in East Bosnia 1992–1995*, that revealed the human side of wartime among ordinary people in desperate circumstances. A *New York Times* book review, commenting on an early preview of the visual novel, described it as "a searing and amusing look at the motley collection of reporters, war profiteers, criminals, soldiers and hapless civilians trapped in a war zone.... Sacco's drawings are stark, realistic visions of the gray, depressing world of a land mangled by artillery shells and deformed by poverty."[21]

Several other young comics artists are currently exploring narratives on war, its causes, and its aftermath. Jason Lutes' graphic novel *Berlin* was initially serialized as a comic and now makes up an eight-volume book. The visually-based story focuses on the lives of two individuals living in Berlin during the final five years of the Weimar Republic. The growing strains and anxieties brought on by the looming National Socialist party as it rises shadow every frame of the novel. Similarly, Chris Lanier's *Combustion* is a parable on war, drawn in the rough, graphic style of German Expressionist woodcuts. Entirely without words, the stark visuals trace the movements of an anonymous soldier, lost in a war-ravaged country.

When extreme tragedies occur, it is often difficult for us to immediately comprehend or internalize the consequences. This is not helped by the tendency of contemporary media to inundate viewers with information. Through computerized virtual imagery, constructed photographs, reality television, and media (where "news" is protracted to fill twenty-four hours a day), we have become inured to visual reality as "truth." Increasingly, this distrust of the media has grown to the extent that many young adults get their news from the comedy channel rather than from the networks.

Comic imagery and graphic styles are so obviously not real that, by contrast, they appear truthful and believable. In 1958 Picasso observed, "We all know that Art is not truth. Art is a lie that makes us realize truth."[22] By personalizing events, often with humor and irony, many contemporary comics, graphic novels, and works of art similarly assist in making difficult circumstances more comprehensible, more so than an endless repetition of televised images.

The September 11, 2001, terrorist attack on the World Trade Center is only gradually showing up as either imagery or subject matter in works of art. One of the few exceptions was David Rees' biting, political comic strip *Get Your War On*, which appeared online soon after the event at

**19**   Art Spiegelman and Françoise Mouly, interviewed by Joey Cavalieri, "Jewish Mice, Bubblegum Cards, Comics Art and Raw Possibilities," *The Comics Journal*, 65 (August 1981), pp. 105–6.

**20**   Art Spiegelman, "Comix 101: Ballbuster, Bernard Krigstein's Life between the Panels," *New Yorker*, July 22, 2002.

**21**   David Rieff, "Bosnia Beyond Words," *New York Times Book Review*, December 24, 2000, p. 5.

www.mnftiu.cc. Within the first two weeks, it received five million hits, including a number of angry e-mails calling him anti-American. Rees conceptualized the strip as a vehicle to comment on the resilience of American culture, making humor out of pain. It provides an alternative history for the weeks following the tragedy at the Twin Towers. The commentary is cynical, lampooning both jingoism and facile idealism. Created with generic figures taken from clip-art, *Get Your War On* follows the phone conversations of anonymous, middle-management office workers as they comment on the current war on terrorism.

> **The works in <u>Comic Release</u> show that the use of comic superheroes and other comic imagery offers a cathartic "release" from the tension and paralyzing anxieties of the times.**

In low-tech videos and black-and-white drawings that are arranged sequentially like comic strips, James Torok comments on the ordeals, pain, and suffering of contemporary life. Prior to September 11, he created a body of work detailing an ordinary man's experience as he learns that he has prostate cancer and then suffers through its debilitating treatment. After the attack on the World Trade Center, Torok expanded his visual narrative to include a series of drawings that traces his personal experience of the tragedy. Starting from the moment of being awakened by his wife and told that the towers had been struck, Torok visually describes the sequence of days that followed for many New Yorkers: watching the smoke from their windows, spending endless hours into the night watching the events over and over on the television, alternating between longing for peace and wanting revenge, and finding it difficult to laugh or reengage in everyday activities. A chance encounter with a disoriented stranger who has been volunteering at Ground Zero brings the visual narrative to a close and offers a form of hope for the future. The crudeness of the drawing and the touchingly human quality of the characters' interactions owe a great deal to the artist's decision to handle these subjects in a cartoon format.

Many of the current generation of artists and graphic novel creators spent vast amounts of their childhood pouring over *Superman*, *Spider-Man*, and *Batman* comics. As Alan Moore reminisces, "I got my morals more from Superman than I ever did from my teachers and peers. Because Superman wasn't real … he was incorruptible. You were seeing morals in their pure form."[23] At a time when our politicians, the clergy, and major corporations are known more for scandals than good works, the classic comics still have a graphic directness and perceived emotional honesty that are rare. Author Michael Chabon recently recalled that comics featuring superheroes were "the

expression of a yearning that a few magic words and an artful hand might produce something—one poor, dumb, powerful thing—exempt from the crushing strictures, from the ills, cruelties and inevitable failures of the greater Creation."[24]

Historically, more than four hundred superheroes appeared in comics during the first half of the twentieth century. Inevitably, most of the comics constituted a form of propaganda created during and following World War II, depicting the victorious Allies vanquishing their enemies. As ideological weapons, comics assisted in encouraging patriotic fervor and demonizing the enemy. As early as 1986, however, cartoon artists such as Alan Moore, in his serial *Watchmen*, began deconstructing superheroes, showing them growing old and losing faith. Considered "the genre's *Ulysses* and *Demoiselles d'Avignon*, a high-gloss paradigm shift,"[25] *Watchmen* made the lives of ordinary bystanders as crucial as the acts of superheroes and led the way for current works by Ben Katchor, Daniel Clowes, and many others.

Contemporary superhero exploits often openly explore issues of sexual orientation, poverty, drugs, teen alcoholism, and race. DC Comics' *Green Lantern* issue 153, for example, examines an incident of gay-bashing involving the superhero's teenage intern, Terry Berg. Growing up, artist Kerry James Marshall was a big fan of the Marvel Comics superheroes: "I was fascinated by the imaginative possibilities, by how much further beyond the realm of the ordinary one could project. That's the world I wanted to spend my time in."[26] In a recent work, *Rythm Mastr*, Marshall seeks to redress the predominance of white superheroes in the past by inserting some racial balance. At the same time, Marshall aims to give his characters a more contemporary context, stating,

> It's one thing to create a set of muscle-bound characters wearing capes—it's another thing to put them in a context where they matter. A lot of black superheroes just ended up fighting petty crime. So the underlying concern of my story was the legendary struggle for the souls of black folk, to borrow a phrase from W. E. B. DuBois.[27]

Marshall's *Rythm Mastr*, in various adventures, contrasts urban reality and cyber technology against ancient African lore.

22   Picasso to De Zayas, 1923, quoted in Peggy Hadden, *The Quotable Artist* (New York: Allworth Press, 2002), p. 211.

23   Alan Moore, interviewed by Sridhar Pappu, "We Need Another Hero," Salon.com, October 18, 2000, <http://archive.salon.com/people/feature/2000/10/18/Moore/>.

24   Quoted in Ken Kalfus, "The Golem Knows," *New York Times Book Review*, September 24, 2000, p. 9.

25   Tom Morton, "Ordinary People," *Frieze*, 67 (May 2000), p. 41.

26   Interview with Kerry James Marshall, "A Thousand Words," *ArtForum* (summer 2000), p. 149.

27   Ibid.

The starkly outlined graphic lines of Marshall's *Rythm Mastr* are echoed in the controversial graphic novel *King* by Ho Che Anderson. Published in serial format, *King* traces the life of Martin Luther King, Jr., with a critical eye. A contemporary "superhero" to many, King in Anderson's rendition is a charismatic leader who is concurrently ambitious, righteous, and not above being morally ambiguous on occasion if necessary to achieve his goals.

In the hands of other contemporary artists, superheroes tend to appear in two forms. Some are futuristic cyborgs, as in the work of Matthew Ritchie, Haluk Akakçe, and Inka Essenhigh. Essenhigh's apocalyptic, deformed, androgynous creatures float across her flatly painted surfaces. They have a Pop, comic sensibility but are generally anonymous; as the artist explains, "I don't paint the faces because the language of cartooning is so readable, it adds unnecessary baggage and takes away from the interchangeability of things. Especially cartoon faces; they become like a tattoo revealing all kinds of sociological information like class or education, forcing the viewer into a too literal reading or a kind of political judgment."[28] Expressionless, undifferentiated, the "heroic" figures in the works of these artists have lost any traces of humanity or individuality.

In the work of Philip Knoll, Luca Buvoli, and Vudor featuring Kunstf★ck, superheroes are by contrast fallible, doubting, anxious, and vulnerable. In a series of painterly and expressionistic works, Vudor and Kunstf★ck depicts a world in which superheroes' spirits are largely broken. The paintings present the masked men defeated and bent over with grief, proclaiming, "Go on world! Hurt each other … kill each other, do anything you want … I just don't care anymore" and "Help! Stop it! Please, the universe is doomed," while in the background the Twin Towers stand against the darkened sky.

The works in *Comic Release* show that the use of comic superheroes and other comic imagery offers a cathartic "release" from the tension and paralyzing anxieties of the times. They provide vehicles for acknowledging our fears and moving on. If life were a classic cartoon, before the terrorist-controlled airplanes destroyed so many lives on September 11, superheroes such as Batman, Spider-Man, or Wonder Woman would have miraculously appeared out of nowhere and saved the day. Unfortunately it didn't happen, and in many works of art and graphic novels, contemporary superheroes have lost their invincibility, much as America has lost its innocence and sense of invulnerability.

Soon after September 11, 2001, several events took place in New York that marked the country's desire to move beyond the tragedy. The Mets resumed playing baseball in Shea Stadium, and both *David Letterman* and the satiric comedy program *Saturday Night Live* returned to the air. In addition to acknowledging the many lives lost in the buildings' collapse, the *Saturday Night Live* broadcast included a solemn tribute to the police and firemen who rushed in to save lives and lost their own. With a number of uniformed representatives standing on stage, the group Five for Fighting performed "Superman (It's Not Easy)," a song that resonates closely with fallible, and ultimately human, depictions of contemporary superheroes:

I can't stand to fly
I'm not that naïve
Men weren't meant to ride
With clouds between their knees

I'm only a man in a silly red sheet
Digging for kryptonite on this one-way street
Only a man in a funny red sheet
Looking for special things inside of me

It's not easy
being me …

Following the performance, then New York City Mayor Rudy Guiliani, who joined the cast of *Saturday Night Live* for the evening, urged New Yorkers to return to normal life. Following his moving remarks, the comedy's executive producer, Lorne Michaels, asked the Mayor, "Is it ok to be funny?" To which Guiliani quipped, "Why start now?"

In the face of atrocities, laughter and humor may be our best remedy and salvation.

**BARBARA BLOEMINK**, is the newly-appointed Curatorial Director of the Cooper-Hewitt National Design Museum of the Smithsonian Institution. Dr. Bloemink formerly served as Director of the Guggenheim Hermitage and the Guggenheim Las Vegas Museums, Director and Chief Curator of the Contemporary Art Center of Virginia, and was the originating Director and Chief Curator of the Kemper Museum, as well as the Director of the Hudson River Museum. Dr. Bloemink has published widely, including five books on various artists, and has contributed to numerous anthologies including *Women in Dada*, *Decorative Excess*, and *Singular Women*. She has organized over ninety museum exhibitions, including *Constructing Reality: Contemporary Photography*; *Re-Righting History: Counter-Narratives by Contemporary African-American Artists*, and *Florine Stettheimer: Manhattan Fantastica*.

Barbara Bloemink would like to thank Ellen Garland, Lisa Goldberg, and David Tussey.

28　Artist in conversation with David Hunt, "A New Grammar of Motion," *Flash Art* (October 2000), p. 76.

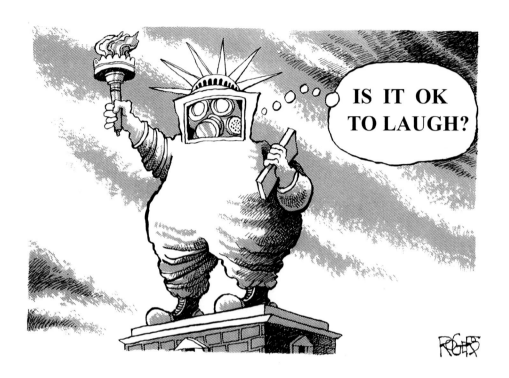

**ROB ROGERS** *Is it ok to laugh*, 2001
From the Pittsburgh Post-Gazette
Ink on Grafix Unishade Bristol board
9 x 12³/₄ inches
Private Collection

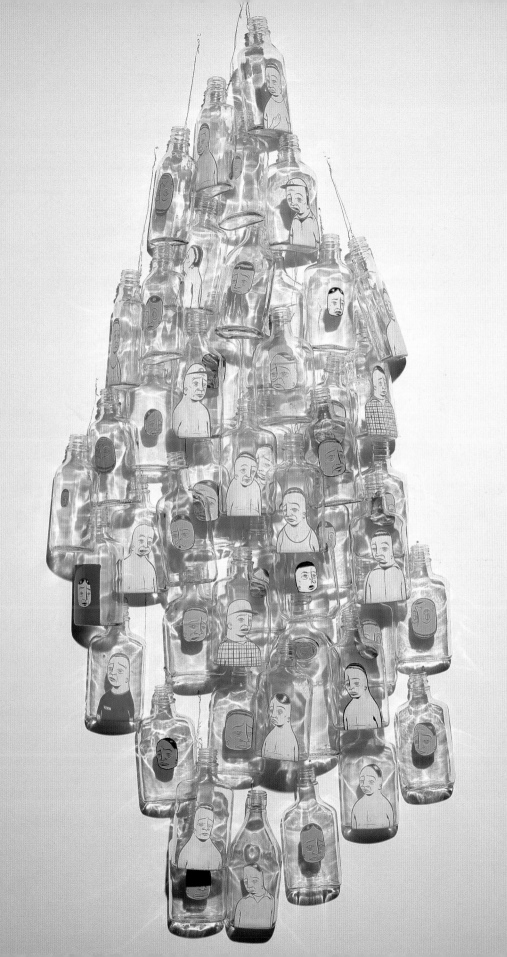

Humor is an inlet. You can seduce people
with it and make them happy, and then you can
sort of slap them across the face and say, 'Look again.'
Humor brings people into a piece, and then they'll
scratch their head and think 'Wow, what am
I laughing at? Maybe this is really not so funny.'

**Nicole Eisenman**

http://artseensoho.com/Art/Tilton/eisenman96/ei6.html; July 24, 2001

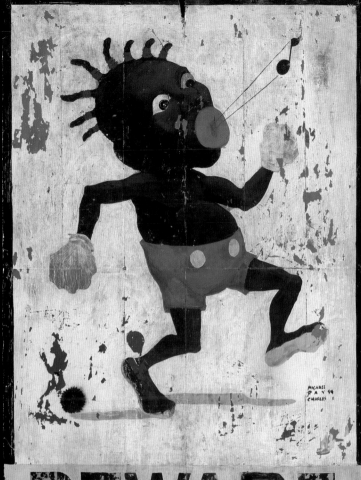

**MICHAEL RAY CHARLES** *(Forever Free) Beware*, 1994
Acrylic latex, oil, wash and copper penny on paper
44 x 30¼ inches
Courtesy Toni Shafrazi Gallery, New York

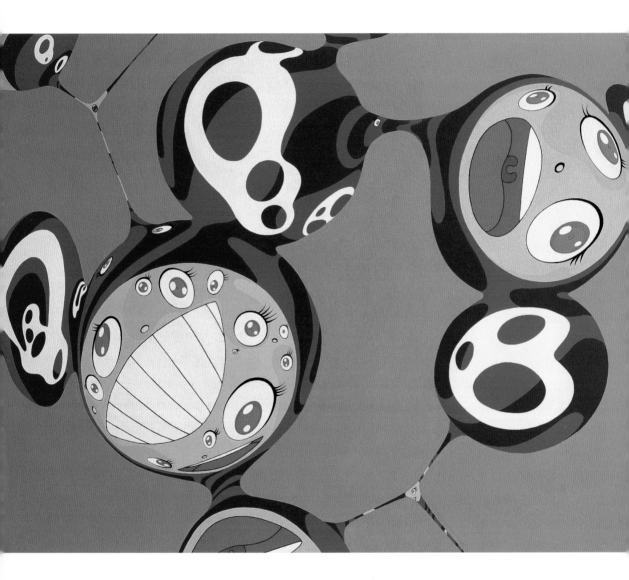

**TAKASHI MURAKAMI** *Blue Black*, 1998
Acrylic on canvas
19 x 25 inches
Courtesy Blum & Poe, Santa Monica, CA

**JAMES KOCHALKA**  *God Wants James Kochalka*, 2001
Acrylic gouache on two-ply Bristol paper
11¼ x 9 inches
Courtesy of the Artist

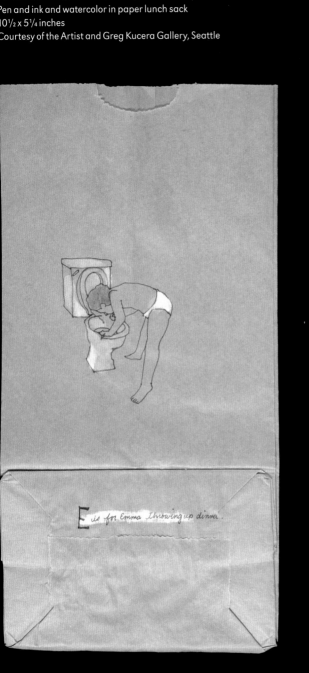

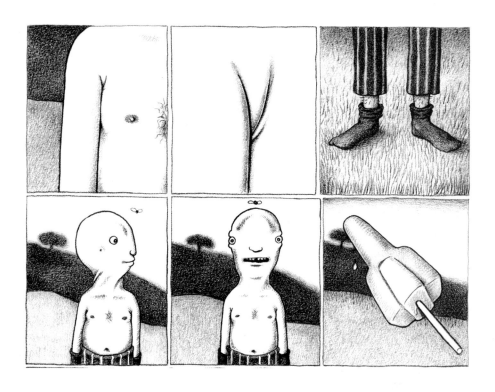

**RENÉE FRENCH**  *Steelhead* (3 pieces), 2001
Black pencil on paper
7 ½ x 11 ¼ inches
Courtesy of the Artist

**WALTER ROBINSON**  *Slag Baby (Babar)*, 2001
Plaster and epoxy
10 x 9 x 9 inches
Courtesy Catherine Clark Gallery, San Francisco

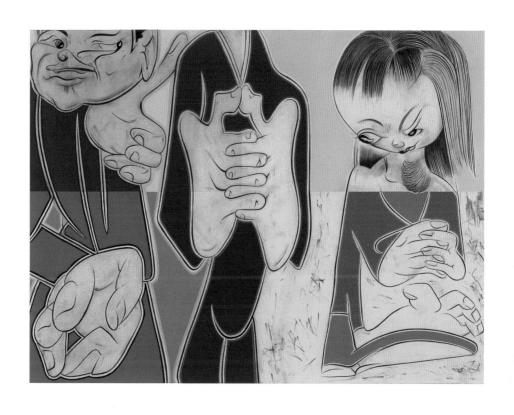

**ELLIOTT GREEN**  *Hold On Tight*, 2001
Alkyd and oil on canvas
42 x 56 inches
Courtesy Postmasters, New York

**DEAN HASPIEL**  *Closet Shut-In*, 2000
Ink brush and pen on bristol board
16¹/₂ x 11 inches
Collection of the Artist

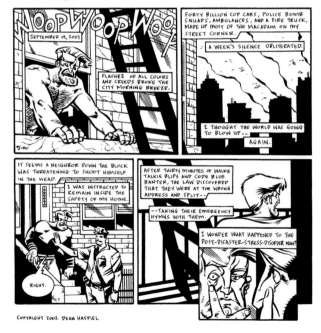

**BLAKE BOYD**   *Death of a Poet*, 2001
Cibachrome on plexiglass
50 x 39 ½ inches (each panel)
Collection of Donna Peret and Ben Rosen, New York
Courtesy Galerie Simonne Stern, New Orleans

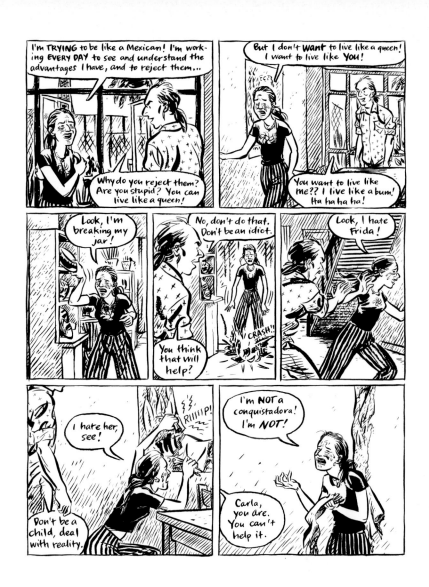

JESSICA ABEL  *La Perdida* (part two, page 42), 2002
India ink on paper
10 1/2 x 8 inches
Collection of the Artist

**REED ANDERSON AND DANIEL DAVIDSON** *Macho Shogun*, 2000
Video stills
Courtesy Clementine Gallery, New York

**PETER KUPER** *Bombs Away*, 1991
Enamel paint, watercolor, color pencil on watercolor paper
15¼ x 12½ inches
Courtesy of the Artist

overleaf:
**NEIL FARBER** *Untitled*, 2002
Colored ink on paper
10 x 12 inches
Courtesy Richard Heller Gallery, Santa Monica, CA

SCHOOL
PICTURE

TOOTH CARE
PRODUCTS

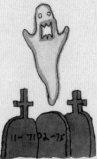

HAUNTED
GRAVEYARD

NORFOLK PINE

TARGET

HORROR

UKALALEE

DRACULA BROTHERS

TIME

KITTEN

FLOWERS

EVIL
DAD

**GRAHAM ANNABLE** *Pacific Time*, 2001
11 x 7 inches
Courtesy of the artist

# How To Make A Zine

By Tom Hall
+
Rick Gribenas

THE MEANS FOR CREATING AND DISTRIBUTING COMIC AND ART ZINES IS AS VARIED AS THE PEOPLE WHO, MAKE AND CONSUME THEM. SO, AS WE SAT DOWN AND TRIED TO REPRESENT THE COMIC/ART ZINE CULTURE AS A WHOLE, WE DISCOVERED WHAT AN ALMOST IMPOSSIBLE TASK THIS WAS. EVERY EXAMPLE THAT EITHER OF US COULD COME UP WITH TO DESCRIBE COMIC/ART ZINES THE OTHER COULD COUNTER WITH A 100% CONTRADICTORY STATEMENT. THE ONE AND ONLY COMMON THREAD THROUGH ALL OF THE DISCUSSION WAS IDENTITY.

NO MATTER WHAT THE ZINE IS ABOUT THE AUTHOR'S START AND REASON FOR PRODUCING IT IS THE SAME.

THE ZINE IS A WAY TO EXPRESS THE AUTHOR'S IDEA IN A (MOST OF THE TIME) CHEAP, REPRODUCIBLE, UNCENSORED, AND EASILY DISTRIBUTABLE MANNER. THE ZINE IS A TOOL FOR SELF EXPRESSION.

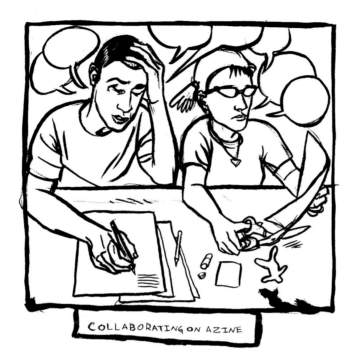

COLLABORATING ON A ZINE

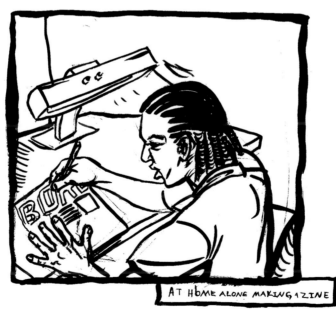

AT HOME ALONE MAKING A ZINE

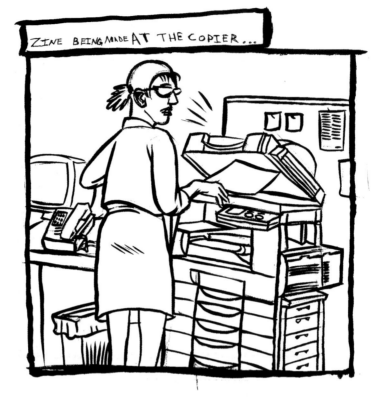

ZINE BEING MADE AT THE COPIER...

FOR THE READER OF COMIC AND ART ZINES, THERE ARE MANY WAYS TO GET YOUR HANDS ONE. IN EVERY TOWN ACROSS THIS EARTH THERE IS SOME ONE BUSY CREATING A ZINE. A LOT OF ZINE MAKERS CAN BE FOUND, THOUGH NOT LIMITED TO, IN LOCAL INDIE-PUNK, AND HIP HOP CULTURES. THERE IS AN INTENSE WORLD WIDE NETWORK OF ZINE MAKERS AND DISTRIBUTERS, ALL OF THEM INDEPENDENTLY CREATING AND FUNDING THE CREATION OF THIS CULTURE. THERE IS NO QUALIFICATION OR PREREQUISITE TO PARTICIPATE IN MAKING OR CONSUMING COMIC OR ART ZINES.

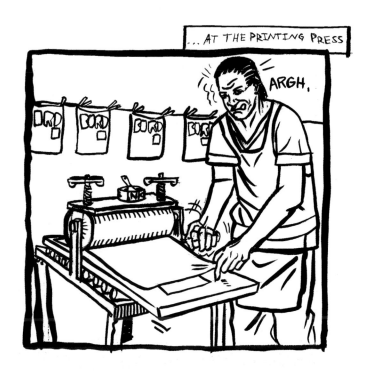

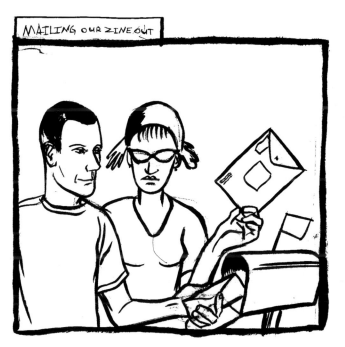

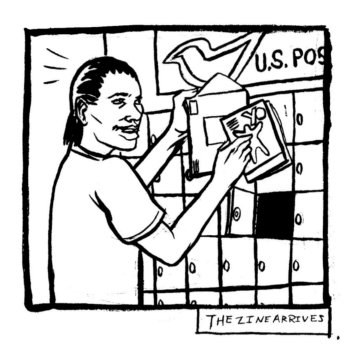

THE ZINE ARRIVES

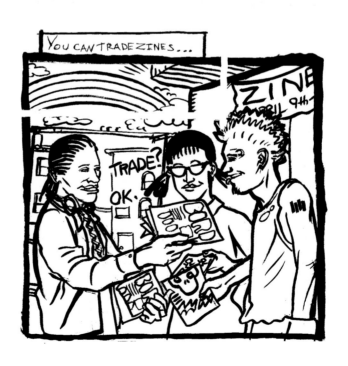

YOU CAN TRADE ZINES...

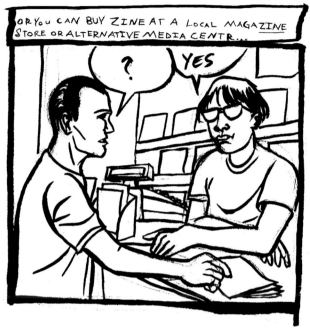

IF YOU CAN IMAGINE IT **THERE** IS A ZINE ABOUT IT.
IF YOU CAN'T FIND IT MAKE IT,
COPY IT, AND START GIVING IT TO ANYONE AND
EVERY ONE WHO WILL READ IT!

RICK GRIBENAS
TOM HALL

BIO
RICHARD GRIBENAS IS A SOUND INSTALLATION AND
PERFORMANCE ARTIST WHO WORKS AS THE EXHI-
BITIONS COORDINATOR AT THE REGINA GOUGER MILLER
GALLERY AT CARNEGIE MELLON UNIVERSITY. HE
WAS THE EMERGING ARTIST OF THE YEAR AT THE
PITTSBURGH CENTER FOR THE ARTS IN 2001,
CREATING A SOUND INSTALLATION, A SOUND PERFORMANCE,
AND A LIMITED EDITION VINYL RECORD. HIS
EXHIBITIONS AND PERFORMANCES HAVE APPEARED IN
NEW YORK, MONTREAL, AND LONDON.

RICK GRIBENAS WOULD LIKE TO THANK TOM HALL
FOR HIS GENIUS SKILLS AND HELP; BRIE ANNE HAUGER,
RACHEL MATTHEWS, TOM HARPEL, NIKKI MCCLURE, ERIC
MEISBERGER, MIKE 'Q' ROTH, DEANNA HITCHCOCK,
GEOFF FROST, MARY TREMONTE, VICKY CLARK, THE
MR. ROBOTO PROJECT, THE BOOKMOBILE PROJECT, AND
THE HUGE ZINE COMMUNITY AS A WHOLE FOR
THEIR GENEROSITY AND SUPPORT.

I rank Schulz with Ghandi in the scope and influence on people in this century. Sure, Ghandi spoke to multitudes, but has anyone counted Schulz's circulation? And the same message is conveyed: Love thy neighbor even when it hurts. Love even Lucy.

**Bill Mauldin**

quoted in David Larkin, ed., *PEANUTS: a Golden Celebration.
The Art and the Story of the World's Best-Loved Comic Strip by Schulz*
(New York: HarperCollins Publishers, 1999), p. 62.

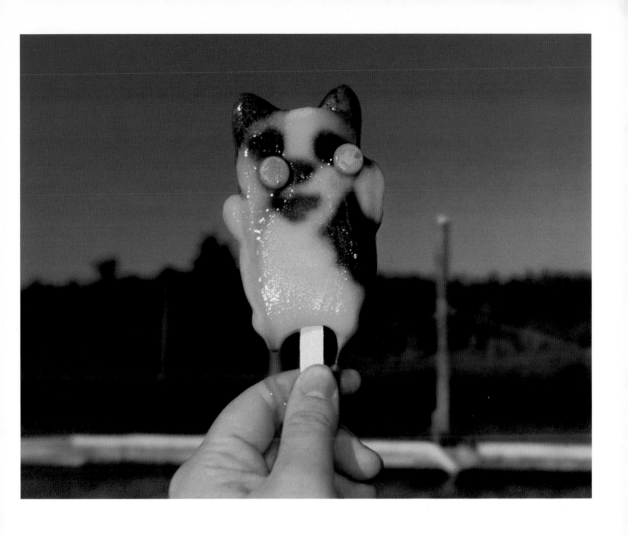

**MEREDITH ALLEN** *Adelaide Ave (Pokemon)*, 2001
C-print
18 x 22 inches
Courtesy of the Artist

**DEBBIE DRECHSLER** *Friends in the Night*, 1992
Brush and ink on paper
10 x 8¾ inches
Courtesy Friends In the Night, Santa Rosa, CA

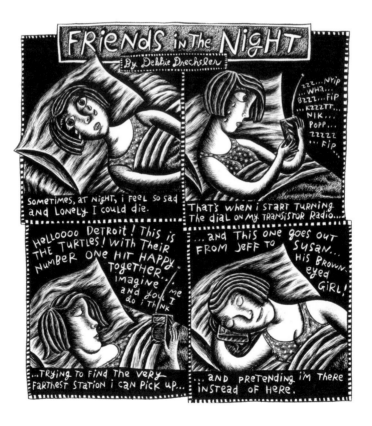

**JAMES STURM** *The Golem's Mighty Swing,* (page 29), 2001
14½ x 11½ inches
Courtesy of the Artist

**MAX**  *Bardín y los Demonios*, 2001
Ink on paper
19½ x 16½ inches
Private Collection

**FABIAN UGALDE**  *Paisaje Caido/ Fallen Landscape*, 2001
Polyvinyl on vinyl. Diptych
63 x 31½ inches
Private Collection
Courtesy Galeria Enrique Guerrero, Mexico

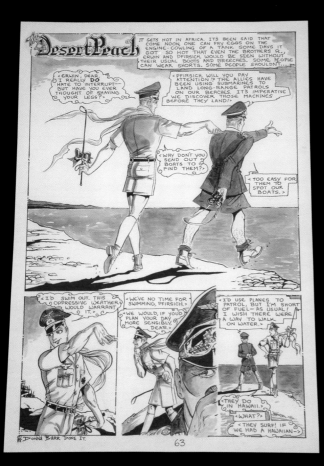

**DONNA BARR** *A Day at the Beach, Desert Peach #3*, 1987
India ink on paper
15 x 10 inches
Courtesy of the Artist

**MIGUEL RODRIGUEZ**  *Considering Informative Action*
*(Self-Portrait with Mask* and *Mike)*, 2000
Fired clay
34 x 21 x 17 inches and 33 x 24 x 21 inches
Courtesy Byron C. Cohen Gallery for Contemporary Art, Kansas City
Photo: Gary Rohman

I didn't want a completely passive viewer. Art means too much to me…. I wanted to make work where the viewer wouldn't walk away; he would either giggle nervously, get pulled into history, into fiction, into something totally demeaning and possibly very beautiful…. I wanted to create something that looks like you. It looks like a cartoon character, it's a shadow, it's a piece of paper, but it's out of scale. It refers to your shadow, to some extent to purity, to the mirror.

## Kara Walker

quoted in Jerry Saltz, "Kara Walker: Ill-Will and Desire in Kara Walker," *Flash Art* 191, (November/December 1996), p. 82; reproduced in Robert Hobbs, *Kara Walker: Slavery! Slavery!* (Washington, D.C.: International Arts and Artists, 2001), p. 36.

THE ENGLISH HAVE ALWAYS ADOPTED A
RELAXED ATTITUDE TO SEXUAL FULFILLMENT

**GLEN BAXTER** *The English have always adopted a relaxed attitude to sexual fulfillment*, 1997
Crayon & ink on paper
30 x 22 inches
Courtesy Modernism Gallery, San Francisco

**SEAN LANDERS**  *Truman Capote*, 1999
Oil on linen
47 x 39 inches
Courtesy Andrea Rosen Gallery, New York
Photo: Orcutt & Van Der Putten, New York

**PETER BAGGE**  *Hate* #4 (cover), 1991
17 x 14 inches
Ink on paper
Collection of Eric Reynolds, Seattle, WA

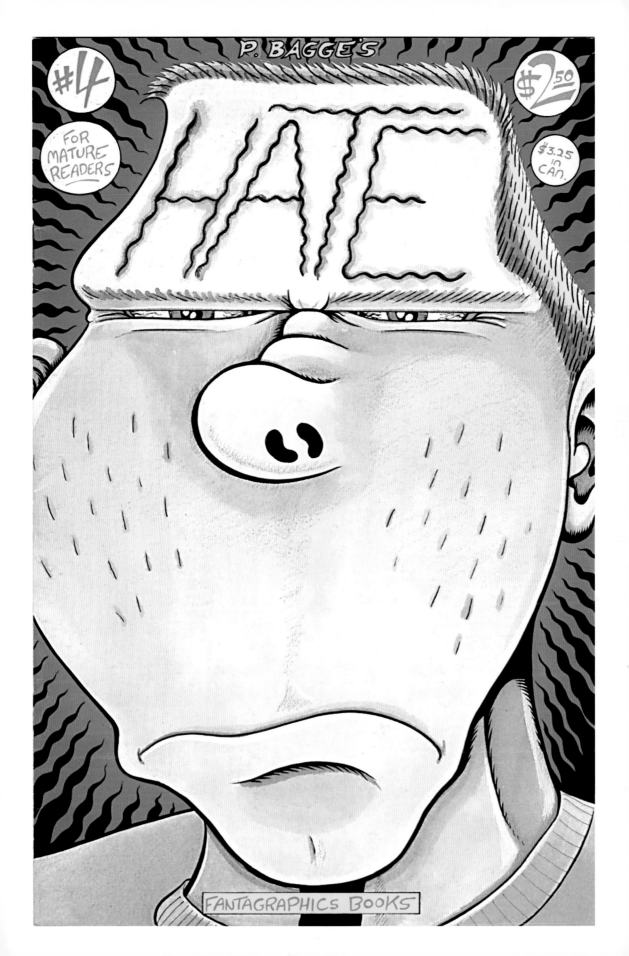

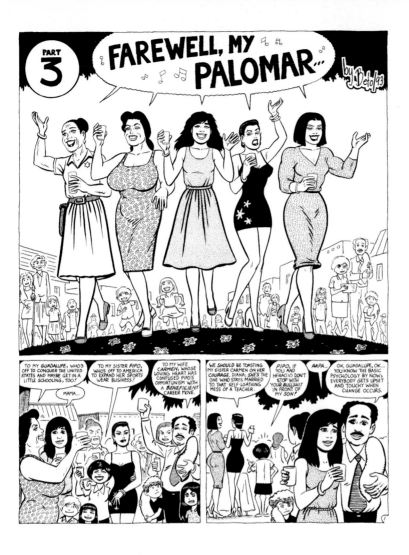

**GILBERT HERNÁNDEZ** *Luba Conquers the World* (page 9), 1994
From *Farewell, My Palomar*
Ink on paper
15 x 10 inches
Collection of Eric Reynolds, Seattle, WA

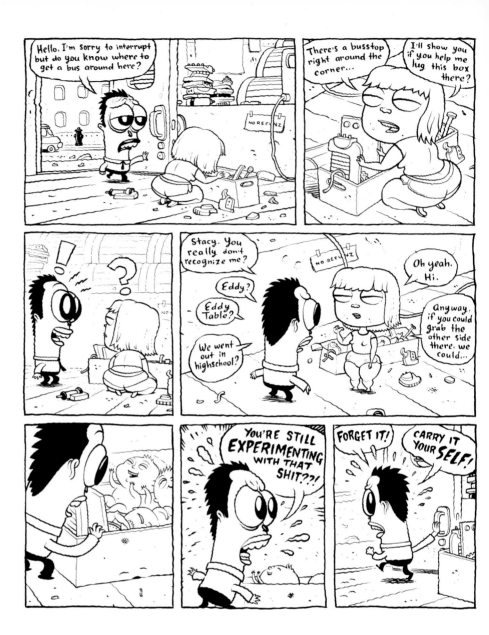

**DAVE COOPER** *Television Program*, 2002
Pen and ink on paper
11 x 8 inches (each page)
Courtesy of the Artist

"Chilling effect" is the legal term for self-censorship on the part of publishers faced with potential litigation. Unfortunately, our financial resources are not strong enough to defend the rights of artists whose interpretations of Disney characters and other corporately owned comic images might well lead to litigation if published. While we believe that the following images are clearly parodies or satires, we recognize that we do not have the financial means to sustain a legal defense if sued. We have therefore made the difficult decision not to reproduce this work. We are not proud of this decision: To create free of trademarks and corporate taste, to not have imagination controlled by corporations who think only of protecting their profit margin—this is crucial to the creation of art and to a free-thinking society.

**NICOLE EISENMAN**  *Lady & the Tramp*, 1998
Oil on Canvas
16 x 12 inches
Courtesy Jack Tilton/Anna Kustera Gallery, New York

**MICHEL BOULANGER** *Nature anxieuse*, 1999
Oil on canvas
63 x 79 inches
Courtesy Galerie Christiane Chassay, Montréal

**GOTTFRIED HELNWEIN**  *American Prayer*, 2000
Mixed media (oil & acrylic) on canvas
84 x 74 inches
Collection of Paul & Cindy Levy
Courtesy Modernism, San Francisco

**NADÍN OSPINA**  *Principe en Extasis*, 2002
Stone
$23^5/_8$ x $10^5/_8$ x $9^1/_{16}$ inches
Courtesy of Galería El Museo, Bogotá

**KAREN FINLEY** *"I don't think Disney is going to release you to play some SPEEDFREAK KUNG FU EXPERT SERIAL KILLER in Reservoir Tigers"*
From *Pooh Unplugged: A Parody*, 1996-1999
Ink on paper
8¼ x 11¾ inches
Courtesy of the Artist and LiebmanMagnan, New York

**JULIA MORRISROE** *Illustration: Honey Tree*, 2001
From © *Disney*
Graphite on paper, carved and painted gypsum board
96 x 96 x ⅝ inches
Courtesy of the Artist

**ELIEZER SONNENSCHEIN**  *Kill Mickey Mouse*, 1999
Acrylic on plaster
17³/₄ x 35¹/₂ x 15³/₄ inches
Courtesy Sommer Contemporary Art, Tel Aviv, Israel

**ANGELA WYMAN**  *Adds Volume (bikini)*, 1999
Gouache on paper
30 x 22 inches
Courtesy the artist

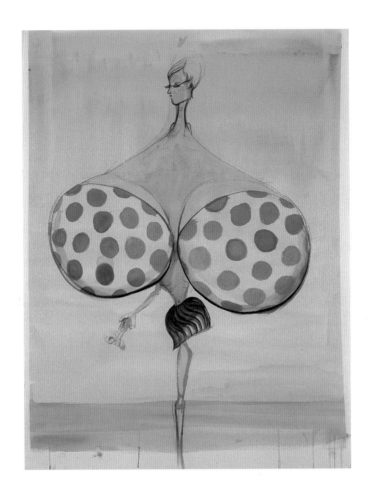

**PETER MITCHELL-DAYTON**  *Harem II*, 1997
Pencil on panel
26 x 19 inches
Courtesy Caren Golden Fine Art, New York
Photo: John Wilson White

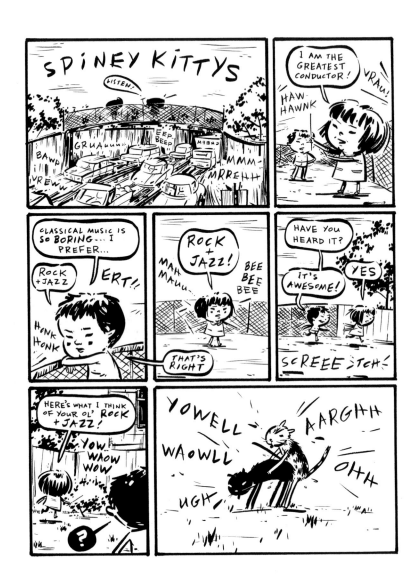

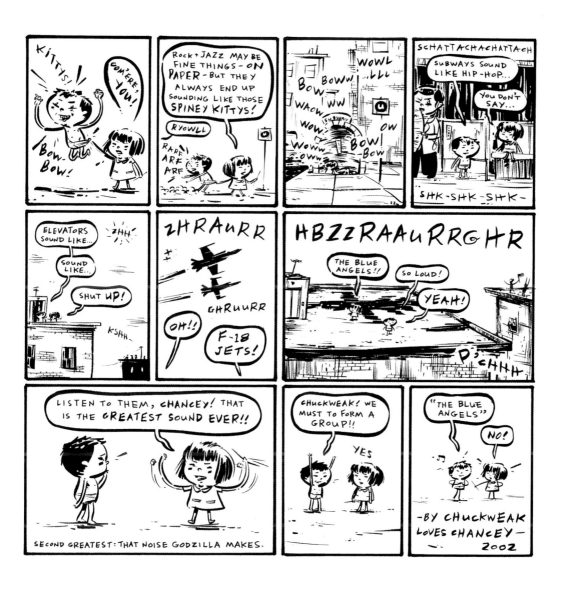

**STEVEN WEISSMAN** *Spiney Kittys* (2 pages), 2002
Ink on paper
7 1/2 x 10 and 10 x 10 inches
Courtesy of the Artist

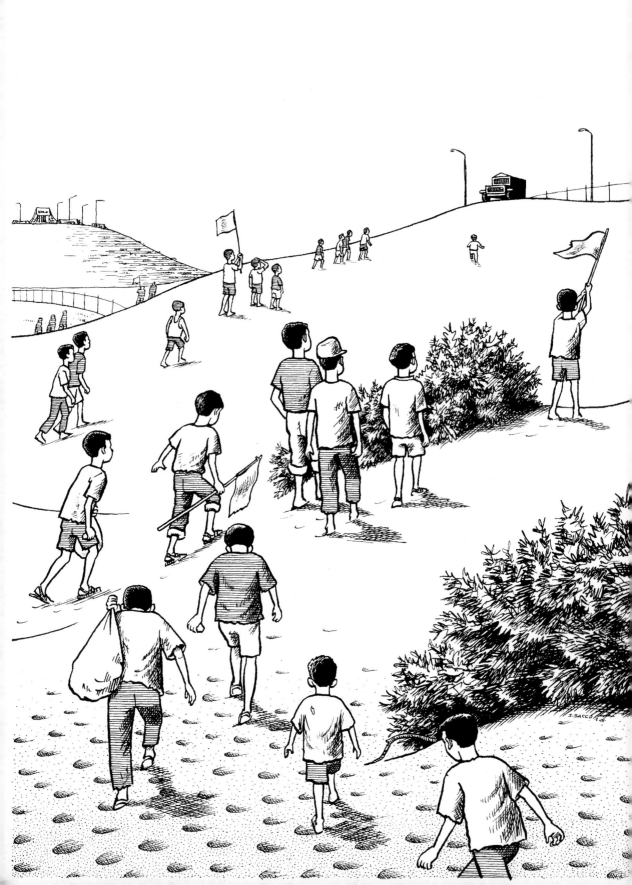

**ARTURO HERRERA** *Night Before Last*, 2002
Graphite on paper
69 x 54 inches
Courtesy Brent Sikkema Gallery, New York

**JOE SACCO** *The Dunes*, 2001
Ink on illustration board
10¼ x 7¼ inches
Collection of Eric Reynolds, Seattle, WA

**MELISSA MARKS** *The Adventures of Volitia: Volitia Attempts Snake River*, 2002
Color pencil on paper
14 x 66 inches
Courtesy Nicole Klagsbrun Gallery, New York

**CHRIS JOHANSON** *Balloon*, 2001
Acrylic and marker on duct tape
14 x 13 x 22 inches
Courtesy Jack Hanley Gallery, San Francisco

**JOHN BANKSTON** *Brooms*, 2001
Oil on linen
72 x 60 inches
Courtesy Jack Shainman Gallery, New York

**VUK VIDOR featuring KUNSTF★CK**  *Doomed*, 2002
Acrylic on canvas
63 x 51¼ inches
Courtesy Galerie Valérie Cueto, Paris

# Exhibited Artists

Jessica Abel
Haluk Akakçe
Laylah Ali
Meredith Allen
Ho Che Anderson
Reed Anderson and
    Daniel Davidson
Graham Annable

Peter Bagge
John Bankston
Donna Barr
Lynda Barry
Glen Baxter
Nick Bertozzi
Alison Bechdel
Michael Bevilacqua
Juliette Borda
Michel Boulanger
Blake Boyd
Bob Burdette
Charles Burns

Enrique Chagoya
Lee Chapman
Michael Ray Charles
Daniel Clowes
Greg Cook
Dave Cooper
Jordan Crane
Jeffrey Czekaj

Dame Darcy
Georganne Deen
Christa Donner
Julie Doucet
Debbie Drechsler
Marcel Dzama

Nicole Eisenman
Inka Essenhigh

Neil Farber
Chris Finley
Karen Finley
Tony Fitzpatrick
Mary Fleener
Renée French
Sally French
Leon Fuller

Seth Gallant
Phoebe Gloeckner
Debbie Grant
Elliott Green
Roberta Gregory
Grennan and Sperandio
Kojo Griffin

Jin Ham
Dean Haspiel
Daniel Heimbinder
Gottfried Helnwein
Gilbert Hernández
Jaime Hernández
Mario Hernández
Arturo Herrera
Peregrine Honig
Ryan Humphrey

Jason Jägel
Cisco Jiménez
Chris Johanson
Pamela Joseph

Brad Kahlhamer
Konstantin Kakanias
Robert Karstadt
Megan Kelso
Philip Knoll
James Kochalka
Peter Kuper

Sean Landers
Carol Lay
Leslie Lew
Jason Lutes

Myfanwy MacLeod
Barry McGee
Matt Madden
Melissa Marks
Kerry James Marshall
Joe Matt
MAX
Linda Medley
Tony Millionaire
Peter Mitchell-Dayton
Julia Morrisroe
Dave Muller
Takashi Murakami

Yoshitomo Nara
Josh Neufeld
Mark Newport

David Opdyke
Nadín Ospina

Joseph Park

Brian Ralph
Ron Rege Jr.
Walter Robinson
Miguel Rodriguez
Rob Rogers
ROY

Joe Sacco
Frank Santoro
Christian Schumann
Amy Sillman
Jeff Smith
Zak Smith
Eliezer Sonnenschein
Al Souza
Art Spiegelman
Ted Stearn
James Sturm

Craig Thompson
Adam Sipe
Jim Torok

Fabian Ugalde

Vuk Vidor featuring Kunstf∗uck

Kara Walker
Chris Ware
Steven Weissman
Peter Williams
Sue Williams
Angela Wyman

Complete as of November 15,
2002. For a full list of zine artists
included in the exhibition, please
visit www.cmu.edu/millergallery.

# Lenders

303 Gallery

Jessica Abel
ACME
George Adams Gallery
Meredith Allen
Ho Che Anderson
Graham Annable

Peter Bagge
Donna Barr
Lynda Barry
Galeria Ramis Barquet
Alison Bechdel
Moises and Diana Berezdivin
Nick Bertozzi
Peter Birkemoe
Blum & Poe
Juliette Borda
Michel Boulanger
Laing and Kathleen Brown
Charles Burns

Cais Gallery
Lee Chapman
Galerie Christiane Chassay
Catherine Clark Gallery
Clementine Gallery
Byron C. Cohen Gallery for
    Contemporary Art
Greg Cook
Dave Cooper
Charles Cowles Gallery
Jordan Crane
Galerie Valérie Cueto

Georganne Deen
Deitch Projects
Christa Donner
Debbie Drechsler

Karen Finley
Mary Fleener
Kenneth L. Freed
Fredericks Freiser Gallery
Renée French
Sally French
Friends in the Night

Galería El Museo
Seth Gallant
Phoebe Gloeckner
Caren Golden Fine Arts
Roberta Gregory
Simon Grennan
Galeria Enrique Guerrero
Jeanette Gurevitch and
    Marcia Adams

Sue Hancock and Ray Otis
Jack Hanley
Dean Haspiel
Richard Heller Gallery
Gilbert Hernández
Jaime Hernández
Mario Hernández
Peregrine Honig
Catriona Jeffries Gallery

Pamela Joseph

Brad Kalhamer
Robert Karstadt
Nicole Klagsbrun Gallery
James Kochalka
Rita Krauss
Greg Kucera
Peter Kuper

Carol Lay
Paul & Cindy Levy
Leslie Lew
David Lusk Gallery
Jason Lutes

Barry McGee
Matt Madden
MAX
Bill Maynes Gallery
Linda Medley
Modernism
Julia Morrisroe
Dave Muller

Josh Neufeld

Donna Peret and Ray Otis
Postmasters
Private Collections
The Progressive Corporation

Brian Ralph
Ron Rege Jr.
Revolution Gallery
Eric Reynolds
Roberts and Tilton
Roebling Hall
Rob Rogers
Andrea Rosen Gallery
Revolution Gallery
ROY

Frank Santoro
City of Seattle, 1% for Art,
    Portable Works Collection
Tony Shafrazi Gallery
Jack Shainman Gallery
Brent Sikkema Gallery
Jeff Smith
Sommer Contemporary Art
Christopher Sperandio
Art Spiegelman
Ted Stearn
Galerie Simonne Stern
James Sturm

Marc Tabourian
Jack Tilton/AnnaKustera Gallery
Craig Thompson
Adrian M. Turner
Ken Tyburski

Anne Vrolyk

Steven Weissman
Works on Paper
Angela Wyman

**PUBLISHED BY D.A.P./DISTRIBUTED ART PUBLISHERS, INC.**, New York,
to accompany the exhibition:

**Comic Release** NEGOTIATING IDENTITY FOR A NEW GENERATION

**THE REGINA GOUGER MILLER GALLERY AT CARNEGIE MELLON UNIVERSITY**
Pittsburgh, PA: January 13—March 21, 2003

**THE CENTER FOR CONTEMPORARY ART** New Orleans, LA: April 11—June 15, 2003

**THE UNIVERSITY OF NORTH TEXAS GALLERY** Denton, TX: August 25—October 18, 2003

**WESTERN WASHINGTON UNIVERSITY** Bellingham, WA: January 12—March 13, 2004

Exhibition organized and circulated by Pamela Auchincloss / Arts Management, New York
With the generous support of Carnegie Mellon University and The Pittsburgh Center for the Arts

Publication © 2002 D.A.P./Distributed Art Publishers, Inc.
*The Comic Release Duo* © 2002 Rob Rogers
*The Power of Suggestion... ...The Suggestion of Power* © 2002 Vicky A. Clark
*The Creative Multiplicity of Comics* © 2002 Ana Merino
*Is it ok to laugh yet?* © 2002 Barbara Bloemink
*How to Make a Zine* © 2002 Rick Gribenas
All images © the Artists unless indicated otherwise
*Superman (It's Not Easy)* © 2000 WMI Blackwood Music, Inc. and Five For Fighting Music. Words and Music by
John Ondrasik. All Rights Controlled and Administered by EMI Blackwood Music, Inc. All Rights Reserved.
International Copyright Secured. Used by Permission.

**DESIGN AND TYPESETTING:** Feel Good Anyway
**MANAGING EDITOR:** Lori Waxman
Printed by Palace Press International, Hong Kong

Not all works illustrated appear in the exhibition.

LIBRARY OF CONGRESS CATALOGING-IN-PUBLICATION DATA

Clark, Vicky A.
Comic release : negotiating identity for a new generation / curated by Vicky Clark and Barbara Bloemink ; essays
by Vicky Clark, Barbara Bloemink and Ana Merino ; original zines by Rick Gribenas and Rob Rogers.
    p. cm.
"Carnegie Mellon University, Pittsburgh: January 14-March 21, 2003, CCA, New Orleans: April 12-June 6, 2003,
University of North Texas, August 25-Oct 31, 2003."
ISBN 1-891024-60-4
1. Comic books, strips, etc.—History and criticism—Exhibitions. 2. Comic books, strips, etc.—Social aspects—
Exhibitions. I. Bloemink, Barbara J. II. Merino, Ana. III. Title.
PN6705.A1 C49 2003
741.5'09—dc21
                2002014624

Carnegie Mellon University and the College of Fine Arts wish to thank the following sponsors for their generous
support of Comic Release: Elizabeth Firestone Graham Foundation, The Heinz Endowments, Regina Gouger Miller
and Marlin Miller, National Endowment for the Arts, Pennsylvania Council on the Arts, Juliet Lea Hillman Simonds
Foundation, Inc., and The Andy Warhol Foundation for the Visual Arts through the Pittsburgh Center for the Arts.

Cover image by Neil Farber